ILLUSTRATION UNZIPPED

La ilustración, hoy A ilustração, hoje L'illustrazione, oggi

promopress

ILLUSTRATION UNZIPPED

La ilustración, hoy A ilustração, hoje L'illustrazione, oggi

Julia Schonlau

Illustration Unzziped
La ilustración, hoy A ilustração, hoje L'illustrazione, oggi

Assistant to editorial coordination: Ana Marques
Edition and texts: Julia Schonlau
Translation: Cillero & de Motta
Art direction: Emma Termes Parera
Layout: Maira Purman
Front cover illustration: Takashi Iwasaki (www.takashiiwasaki.info)
Back cover illustrations: Guillaumit, *Falling* (www.guillaumit.com),
Isabelle Arsenault, *Rêves d'enfance IV*, 2006

Copyright © 2012 Promopress for English / Spanish / Portuguese / Italian edition

PROMOPRESS is a brand of:
PROMOTORA DE PRENSA INTERNACIONAL, S. A.
Ausiàs March, 124
08013 Barcelona, Spain
Tel.: +34 93 245 14 64
Fax: +34 93 265 48 83
E-mail: info@promopress.es
www.promopress.es
www.promopresseditions.com

First published in English / Spanish / Portuguese / Italian: 2012

ISBN: 978-84-92810-61-1

Printed in Spain

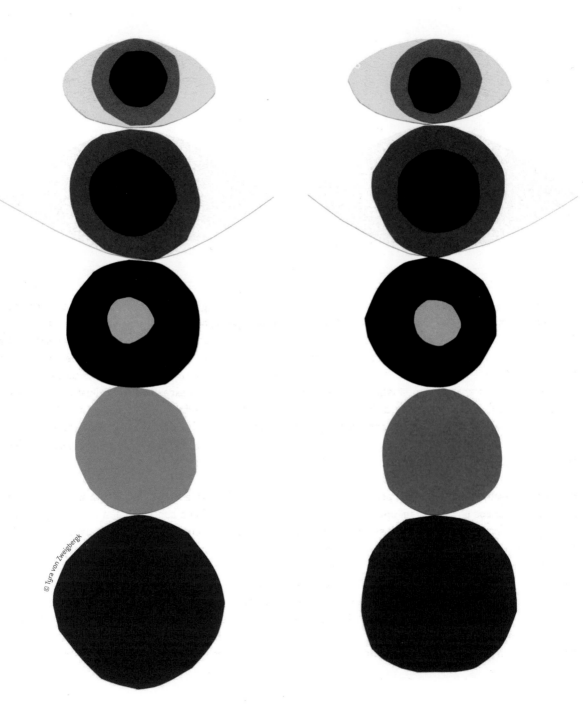

© Tyra von Zweigbergk

This book presents a collection of contemporary artists and illustrators who have established their own style. Some of them have successfully adapted their work to more commercial uses, while others are seeking to break through into the art market.

With only a few exceptions, the illustrations presented in this book are personal works. The artists were free to choose their subject matter, and the choices they have made tell us about their life, the culture they have absorbed, and the aesthetic they aspire to.

Este livro apresenta uma seleção de artistas e ilustradores contemporâneos que definiram um estilo muito próprio. Alguns adaptaram com sucesso o seu trabalho a fins mais comerciais, enquanto outros procuram afirmar-se no mercado da arte.

Salvo alguns casos excecionais, as ilustrações que constam da presente obra representam trabalhos pessoais. Os artistas tiveram toda a liberdade na escolha da temática e as suas opções descrevem-nos a sua vida, a cultura que absorveram e a estética a que aspiram.

En este libro figura una colección de artistas e ilustradores contemporáneos que han definido su propio estilo y encontrado una manera personal de expresarse. Algunos han adaptado con éxito su trabajo a usos más comerciales, mientras que otros tratan de abrirse paso en el mercado artístico.

Con sólo algunas excepciones, las ilustraciones presentadas aquí son trabajos personales. Los artistas pudieron escoger libremente el tema de su obra, y tales elecciones nos revelan aspectos de su vida, la cultura que han absorbido y la estética a la que aspiran.

Questo libro presenta una raccolta di artisti e illustratori contemporanei che sono riusciti a trovare il proprio stile personale. Alcuni di loro si sono adattati a lavorare in contesti più commerciali, con ottimi risultati, mentre altri stanno cercando di farsi strada nel mercato dell'arte.

Con pochissime eccezioni, le illustrazioni presentate in questo libro sono opere personali. Gli artisti sono stati liberi di scegliere il loro tema e sono proprio le scelte che hanno realizzato a fornirci dati sulle loro vite, sulla cultura che hanno assorbito e sull'estetica cui aspirano.

Rose Blake

www.rose-blake.co.uk

United Kingdom

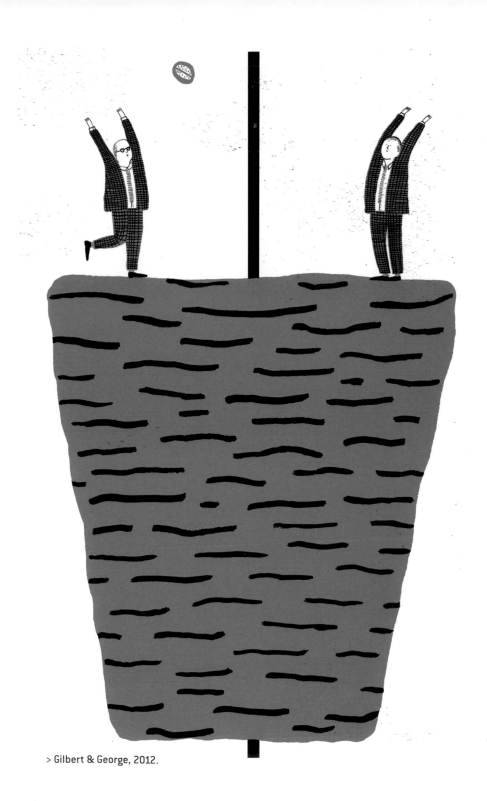

> Gilbert & George, 2012.

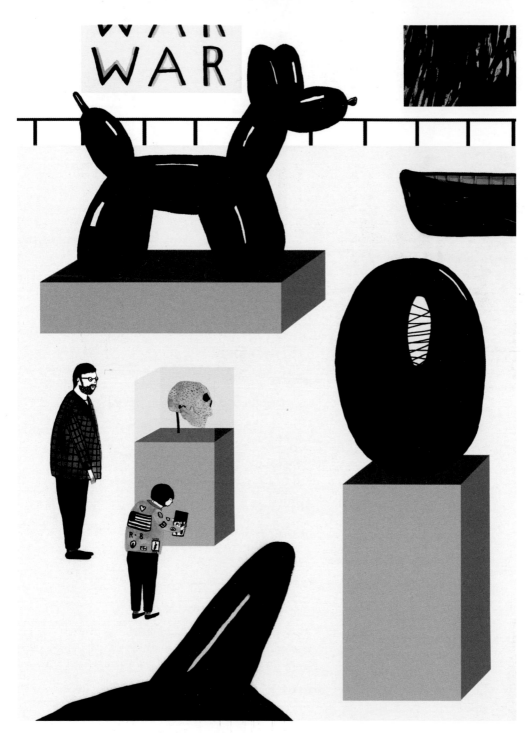

> The Diamond Skull, 2011.

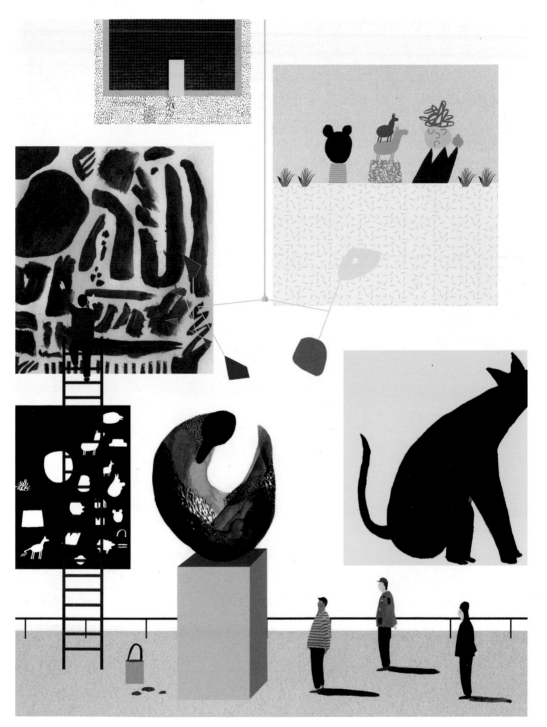

> In the Gallery, 2012.

Oscar Bolton Green

www.oscarboltongreen.com

United Kingdom

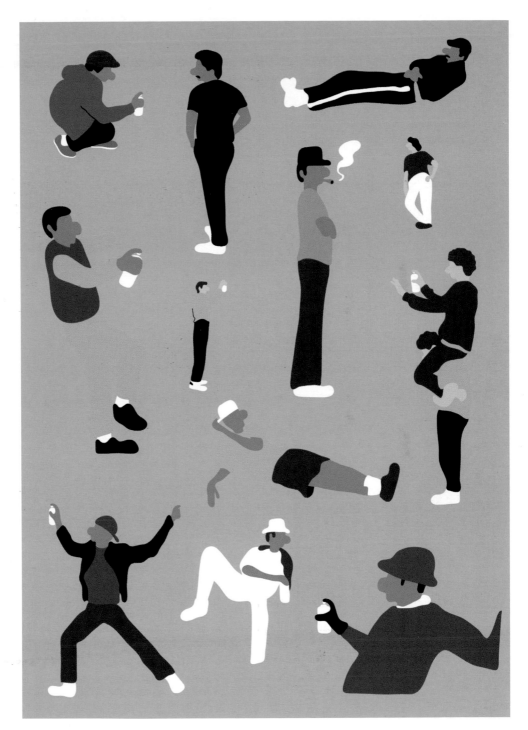

> Untitled, 2011.

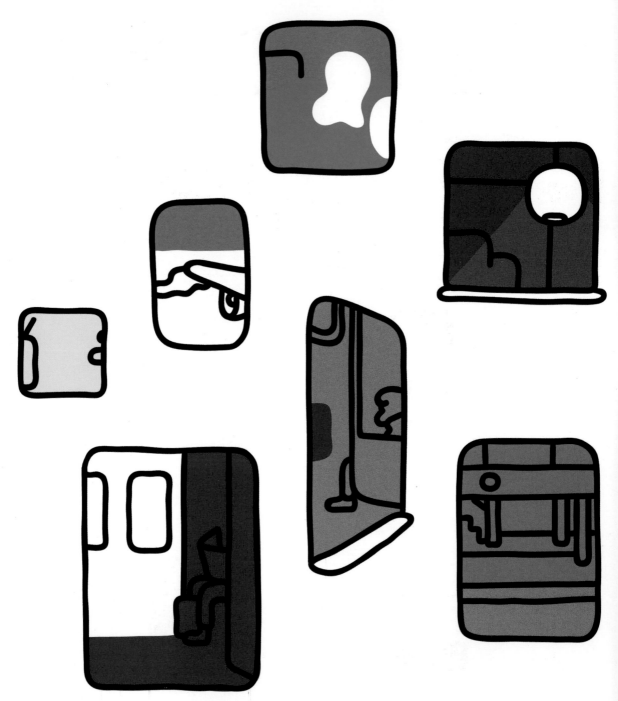

> Untitled, 2012.

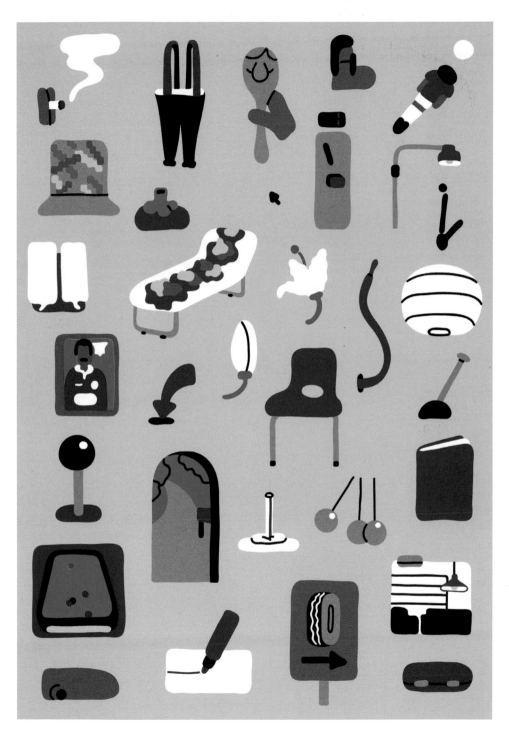

> Untitled, 2012.

Celyn Brazier

www.celynbrazier.com

United Kingdom

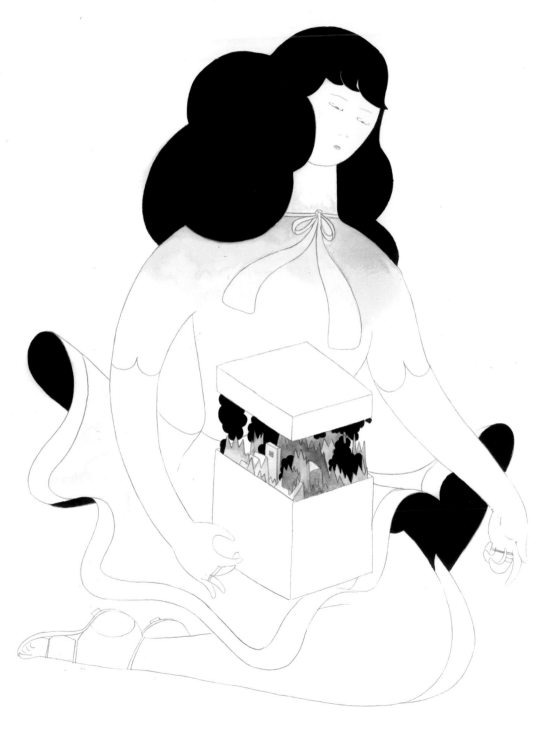

> Yellow Woman. 2012.

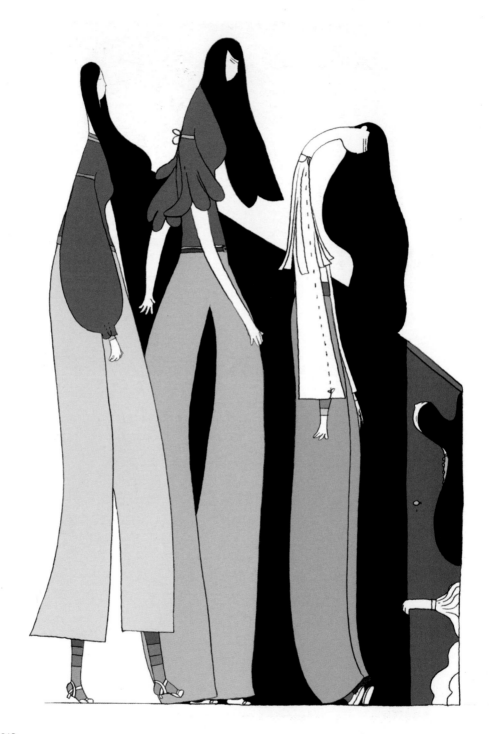

> Tall Women, 2012.

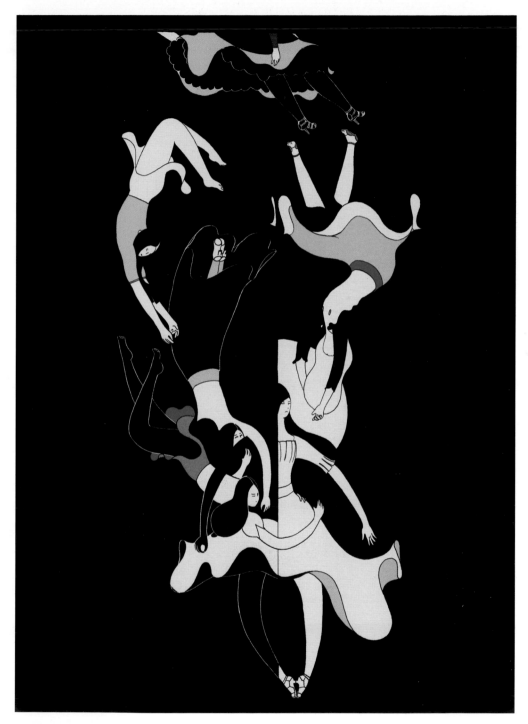

> Falling Ring, 2012.

Soo
Choi

www.thisissoo.com

South Korea

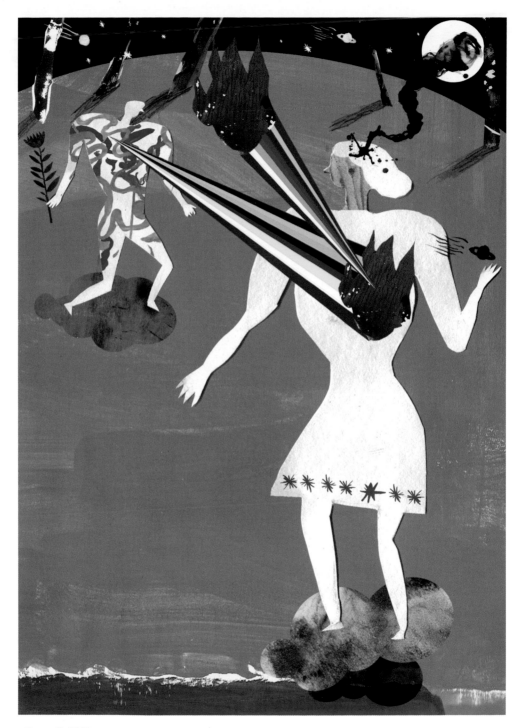

> Yester U, 2012.

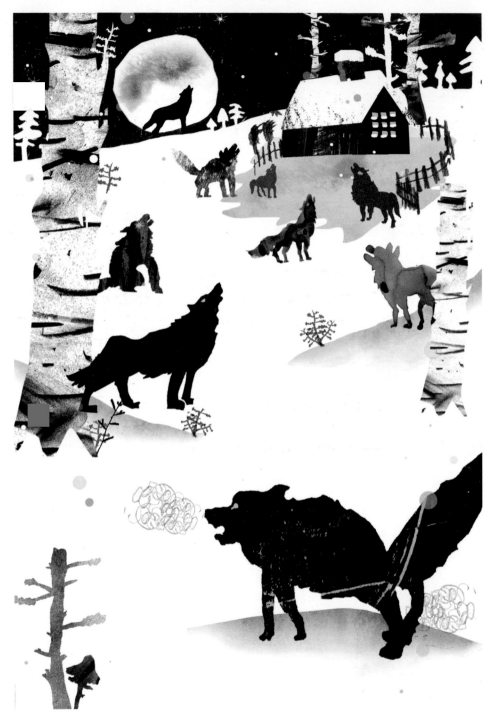

> Company Wolves, 2012.

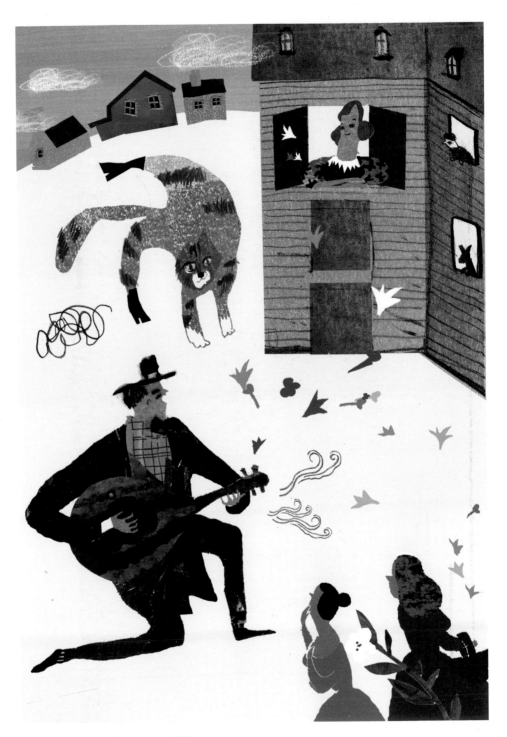

> Puss in Cats Lover's Serenade, 2012.

María
Corte

www.mariacorte.com

Spain

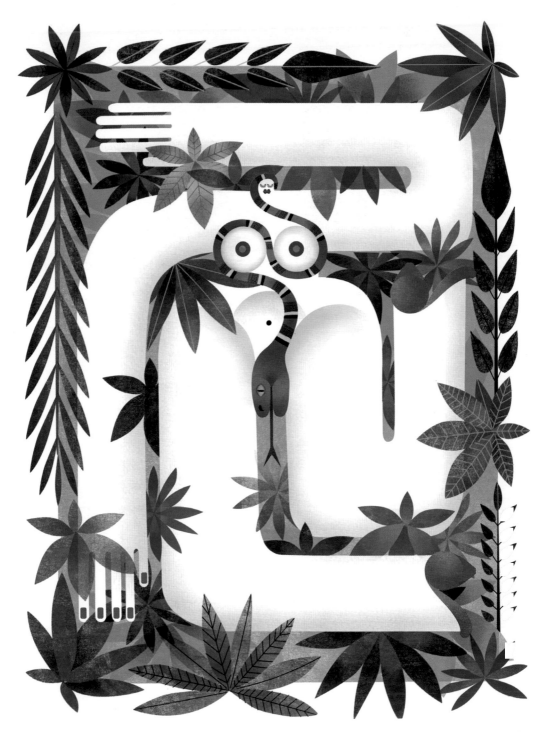

> Misogyny, 2012.

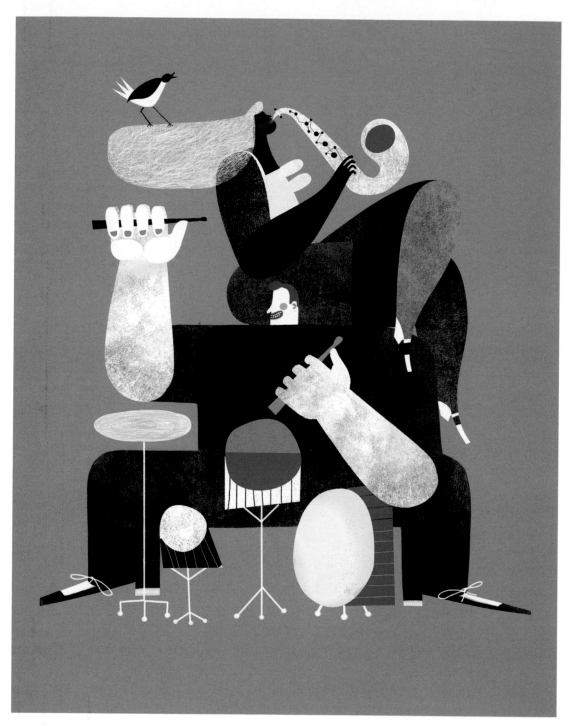

> Jazz Manouche, 2010.

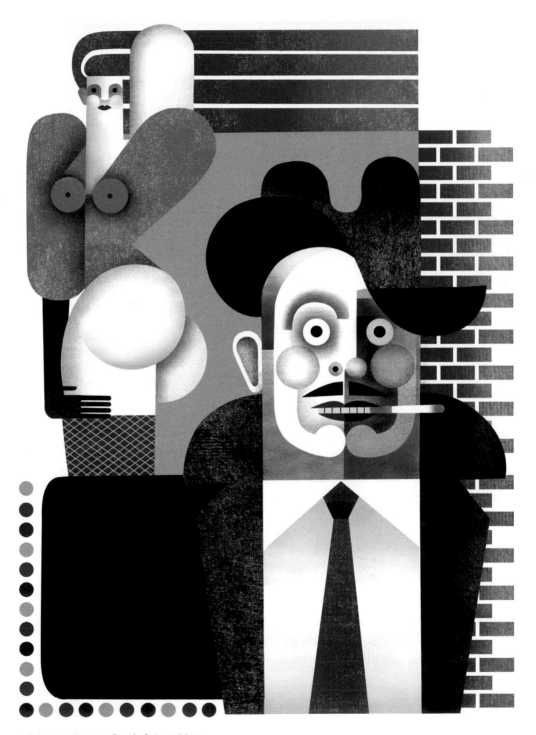

> Tribute to Ernesto García Cabral, 2011.

Das Kopf / Laura Parette

http://daskopf.ultra-book.com

France

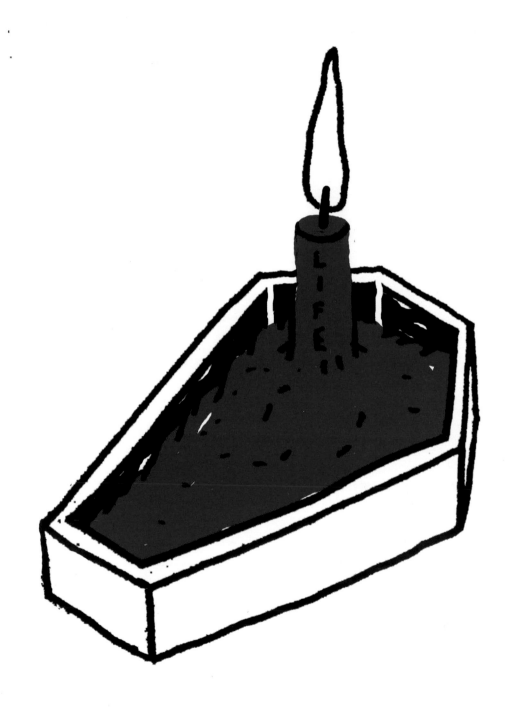

> Untitled, 2012.

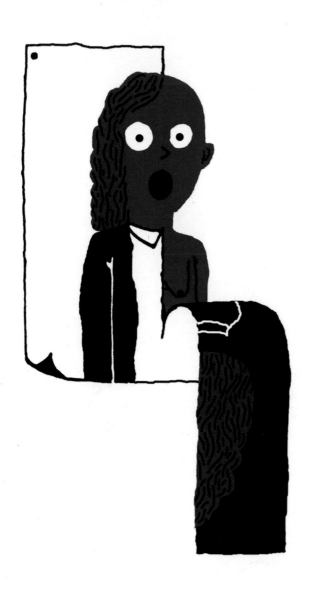

LES FILLES DES MAGAZINES

> Untitled, 2012.

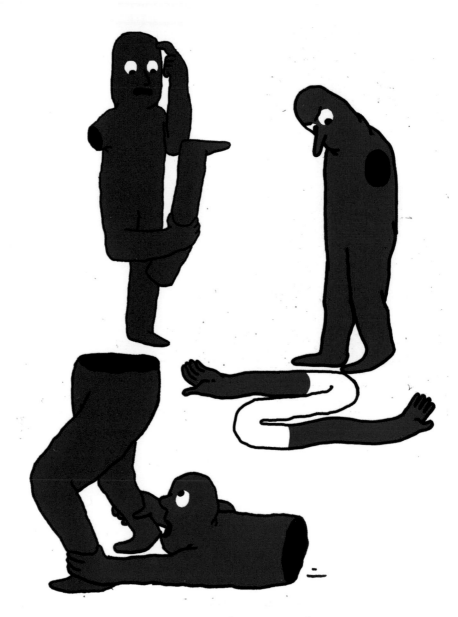

LA VIE C'EST TRÈS
PAS FACILE

> Untitled, 2012.

Dmytro Didora

www.dmytrodidora.com

Ukraine

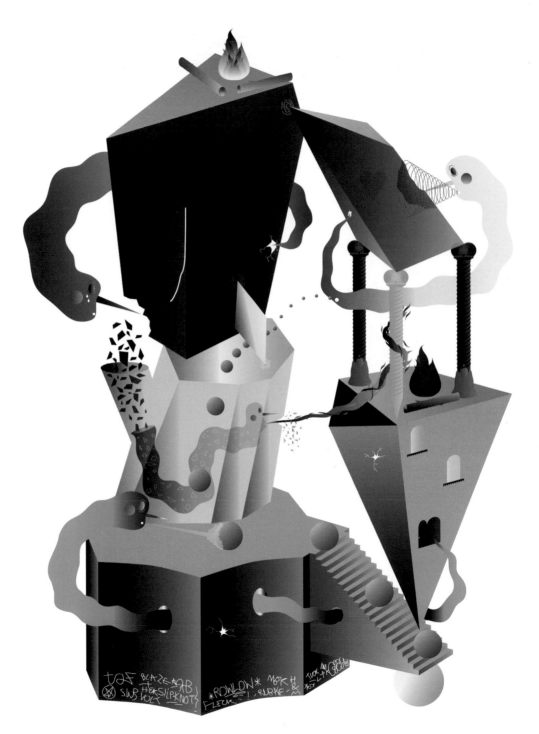

> Circle, 2010.

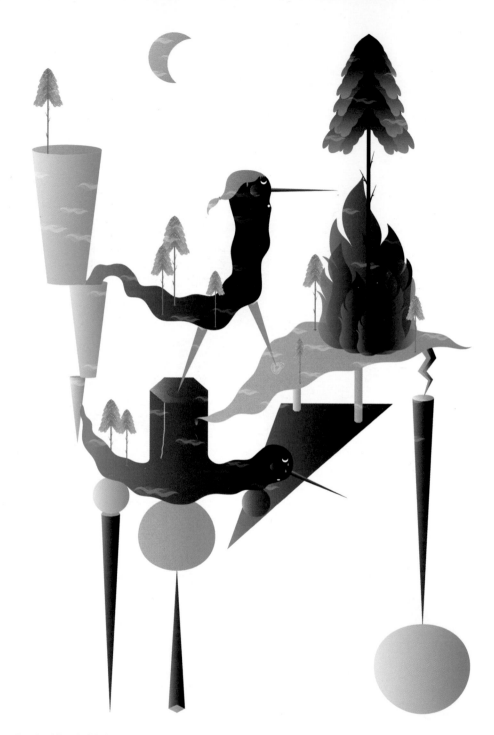

> Death of Death, 2010.

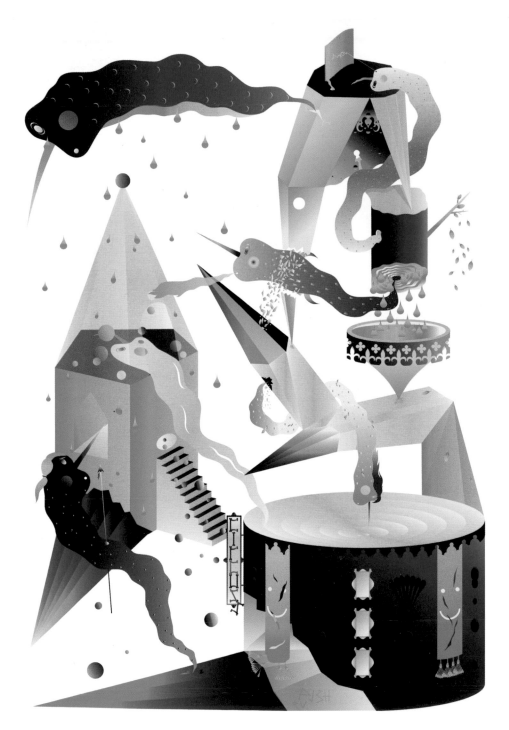

> Circus Tragedy, 2010.

Sue
Doeksen

www.suedoeksen.nl

The Netherlands

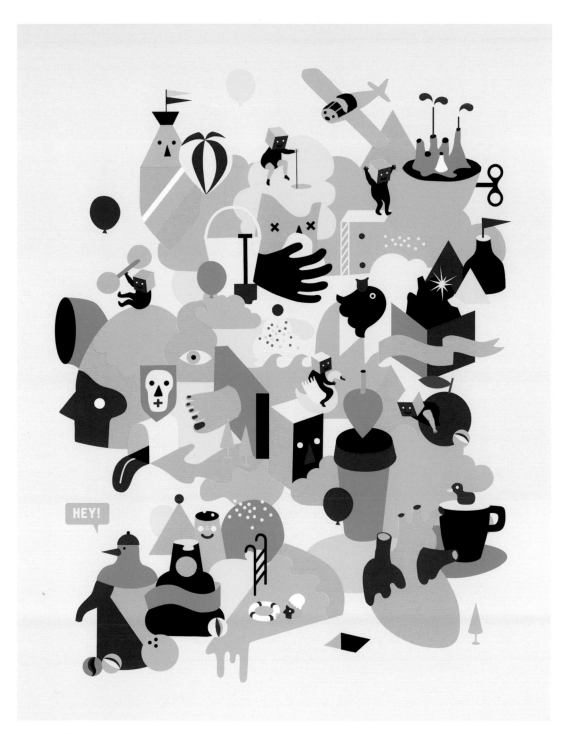

> Scape, 2011.

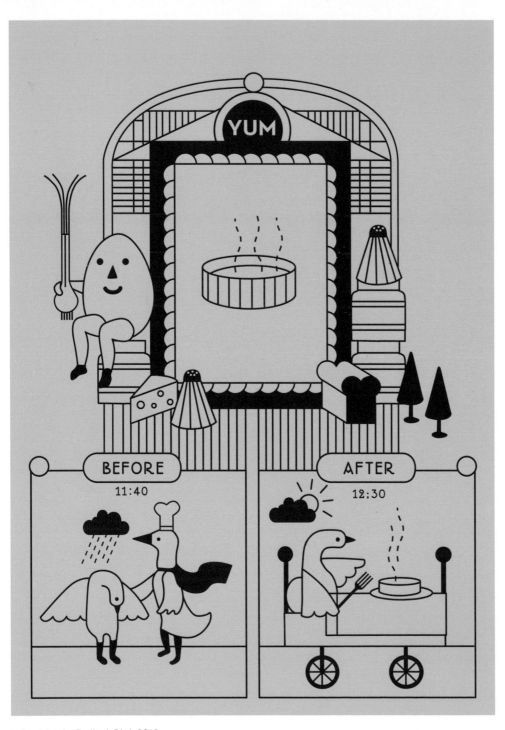

> Food for the Badluck Bird, 2012.

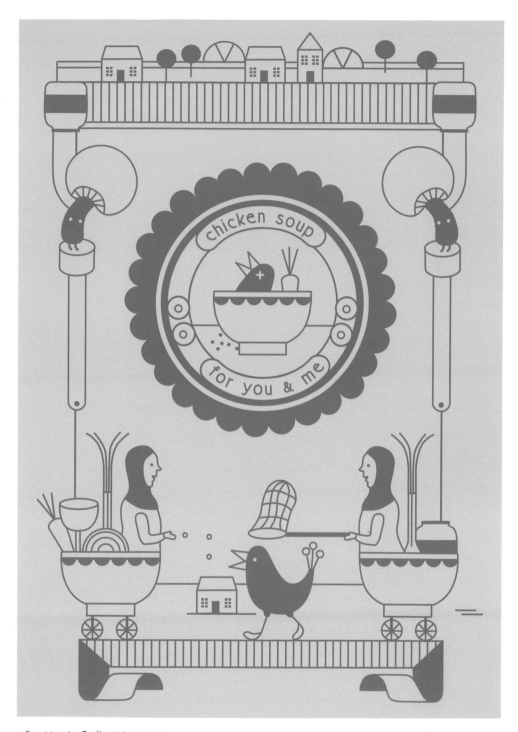

> Food for the Badluck Bird, 2012.

Tom
Edwards

www.edwardstom.com

United Kingdom

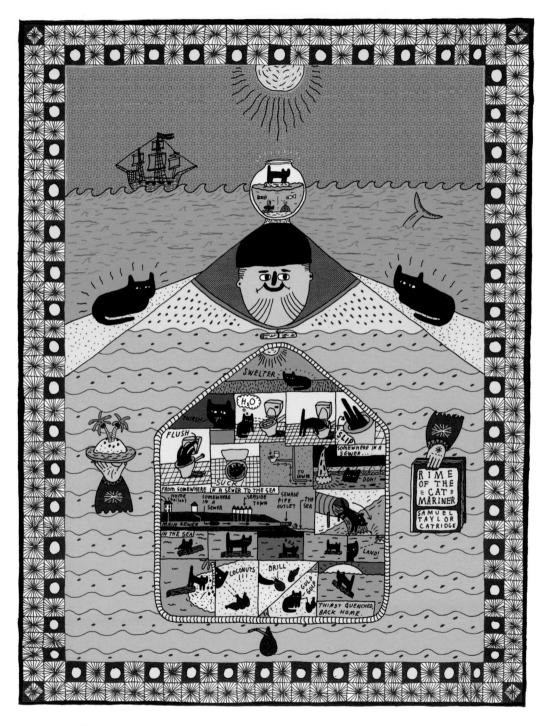

> Nine Tales, 2012.

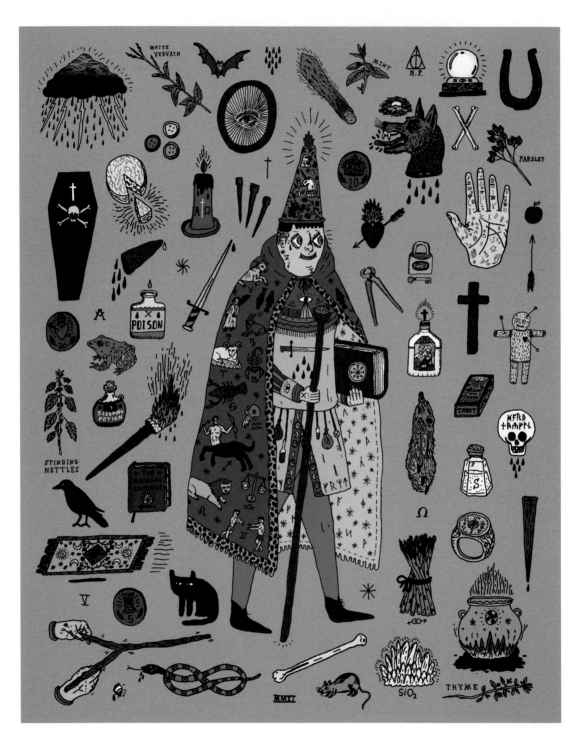

> Wizard and a Series of Magical Objects, 2012.

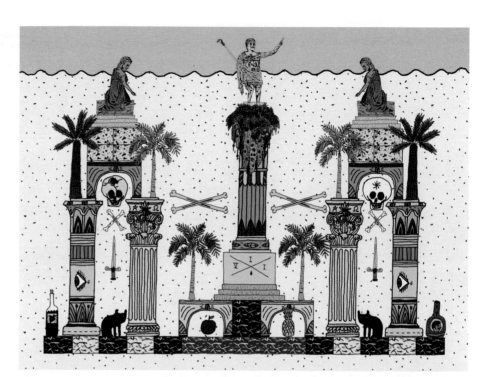

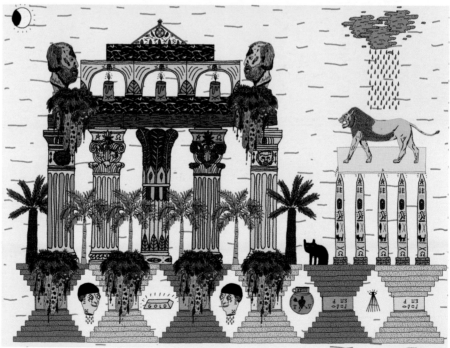

> Granimator Wallpaper, 2012.

Leonardo Flores

www.leonardoflores.com

Spain

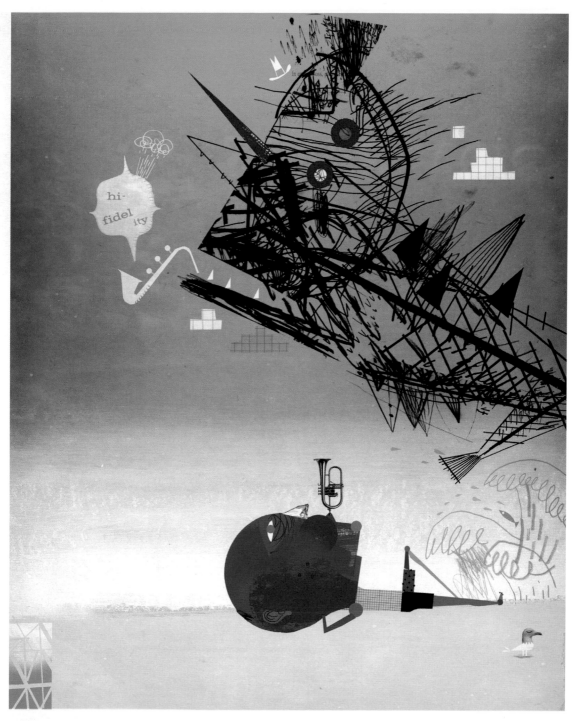

> Dave Douglas, 2008.

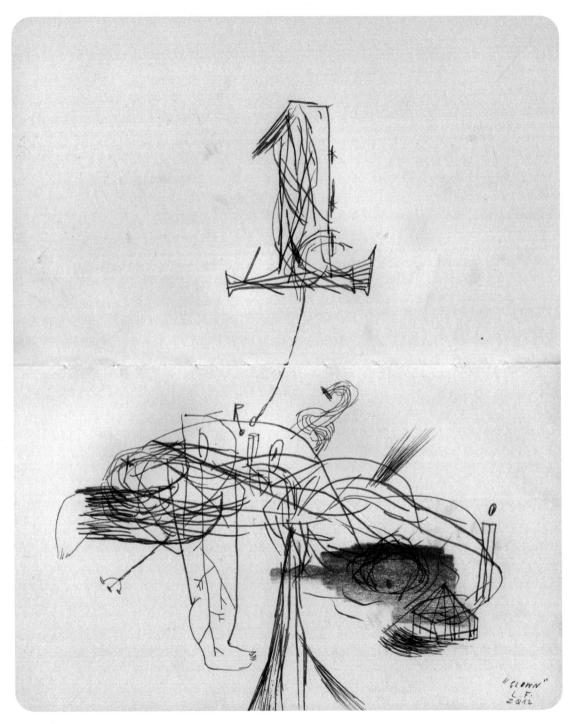

> Clown, 2012.

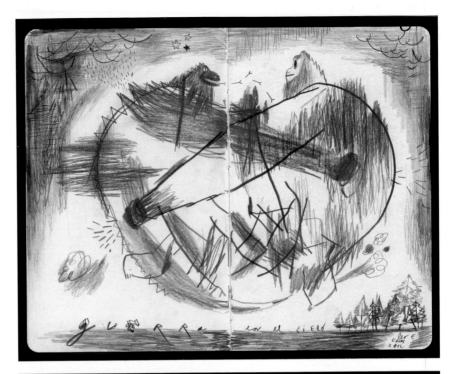

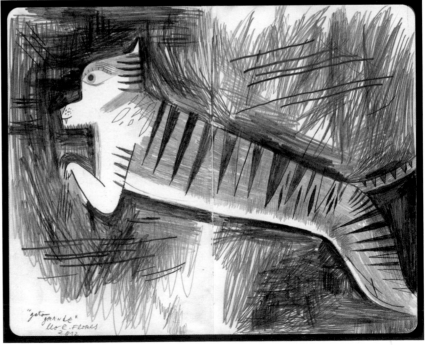

> War in the Sky – Big Cat, 2012.

Golden Cosmos/ Doris Freigofas, Daniel Dolz

www.golden-cosmos.com

Germany

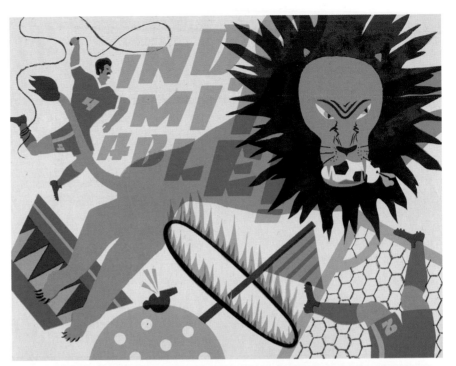

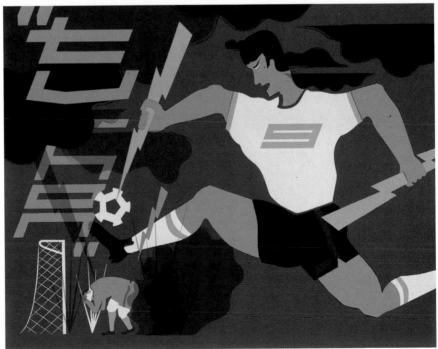

> Glorious Types, 2010.

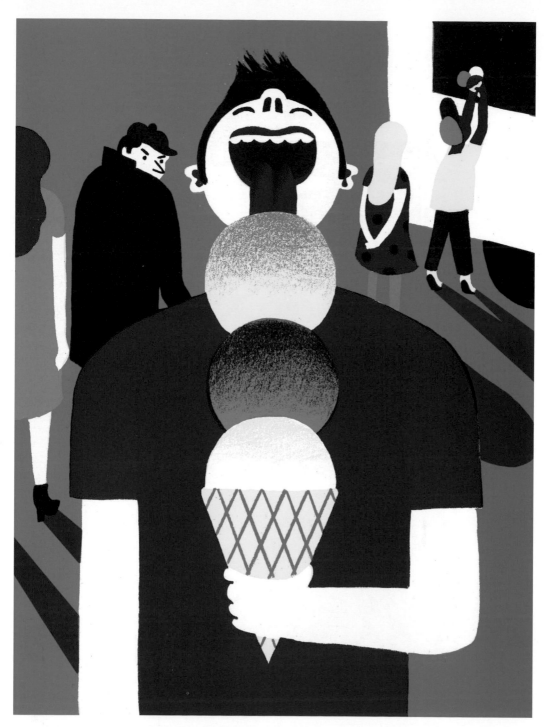

> Mark Twain: Sonntagsheiligung in Deutschland, 2012.

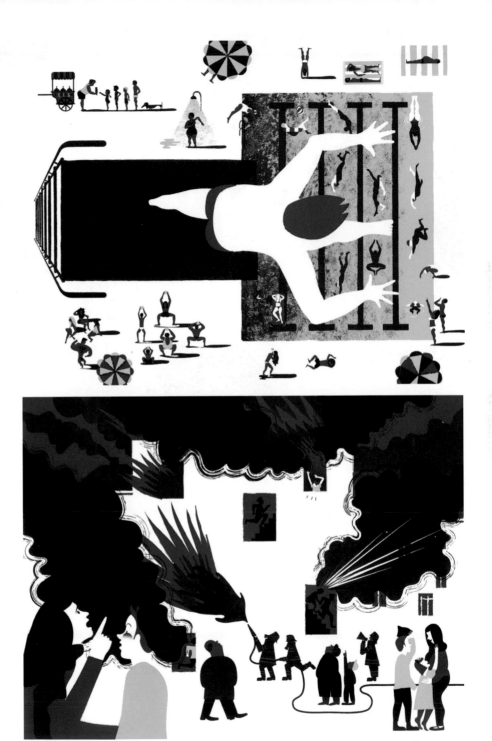

> Von einem, der auszog das Fürchten zu lernen, 2010.

Christina Gransow

www.christinagransow.de

Germany

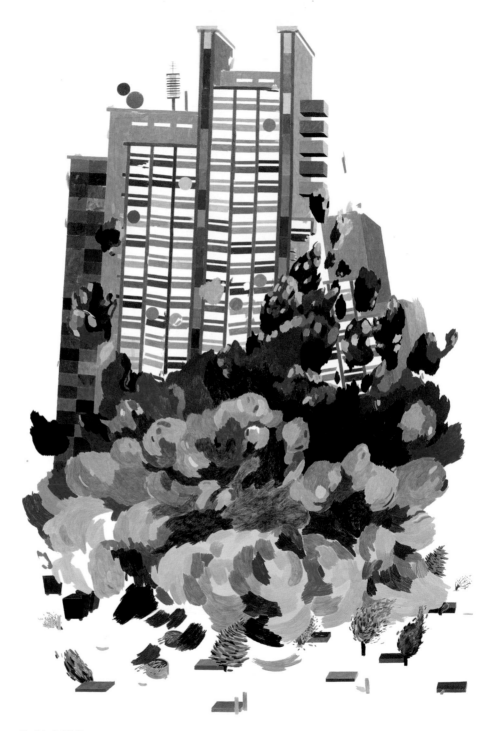

> Untitled, 2012.

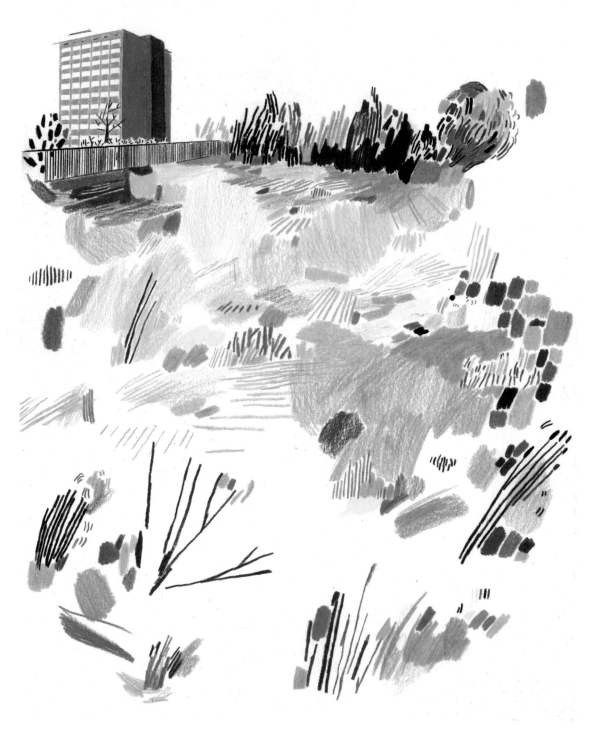

> Untitled, 2011.

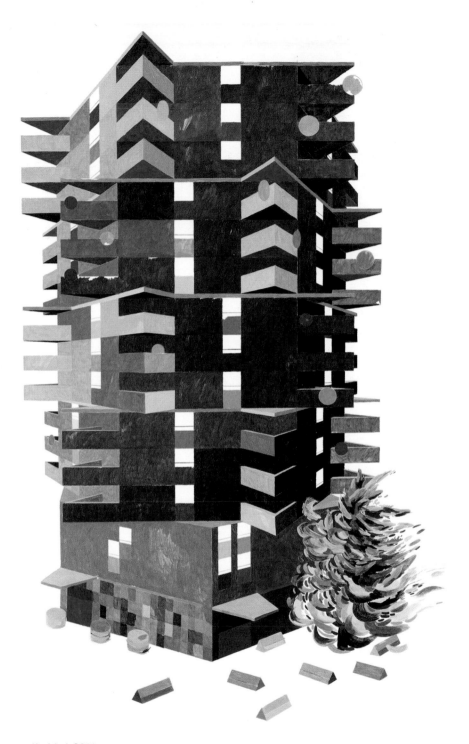

> Untitled, 2011.

Tom Haugomat

www.lespetitestruffes.blogspot.de

France

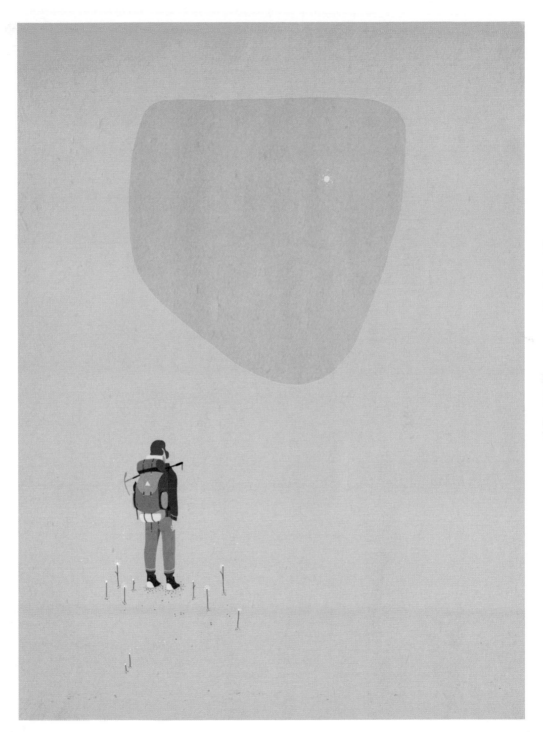

> Montagne, 2012.

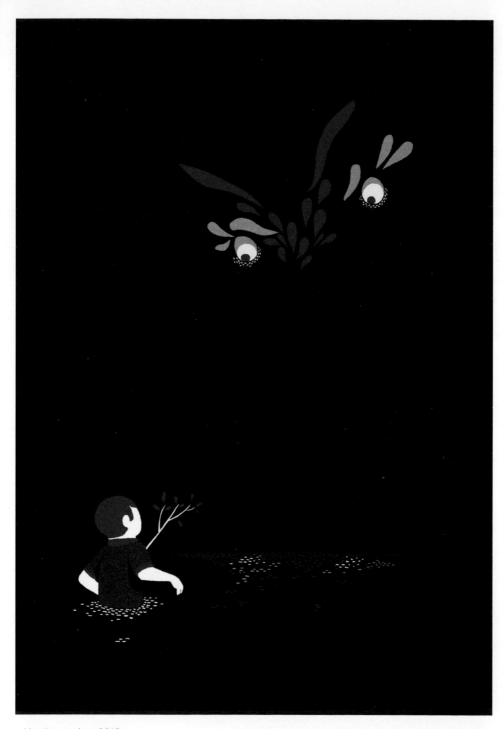

> Marche ou rêve, 2012.

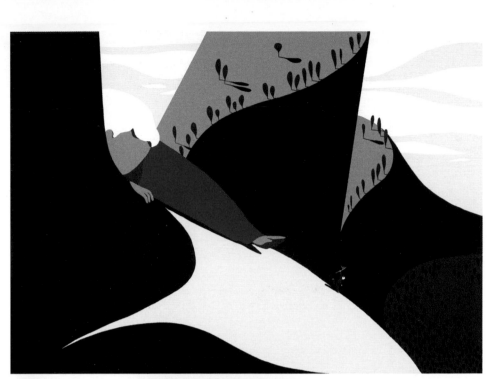

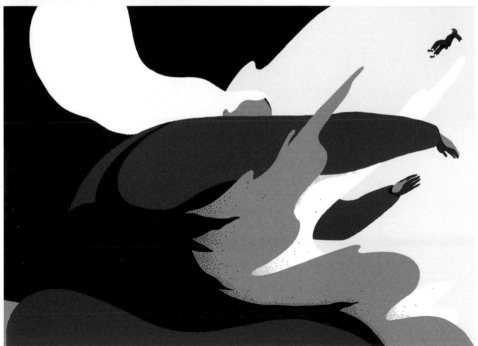

> Marche ou rêve, 2012.

Lea Heinrich

www.leaheinrich.blogspot.de

Germany

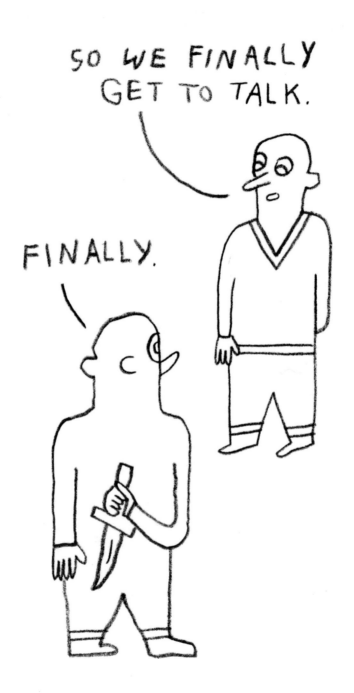

> I Have a Dagger, 2009.

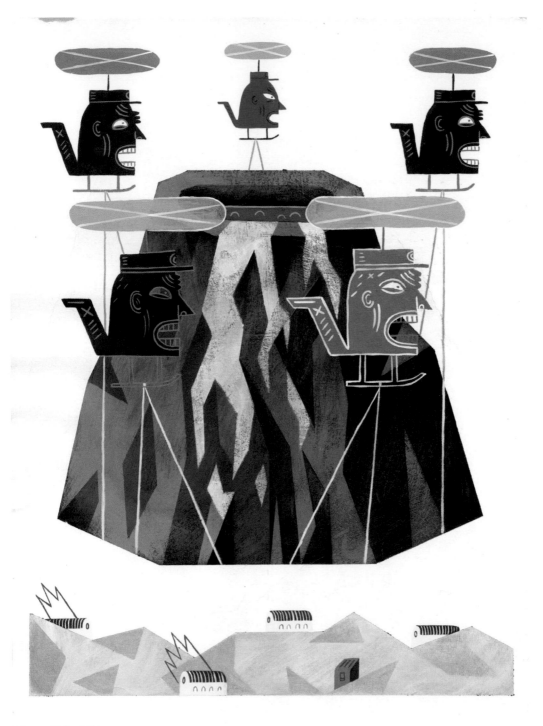

> Supervillain, 2011.

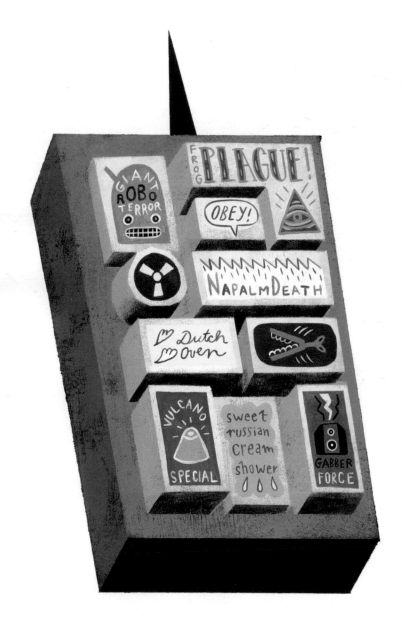

> Supervillain, 2011.

Matthew Hodson

www.matthewthehorse.co.uk

United Kingdom

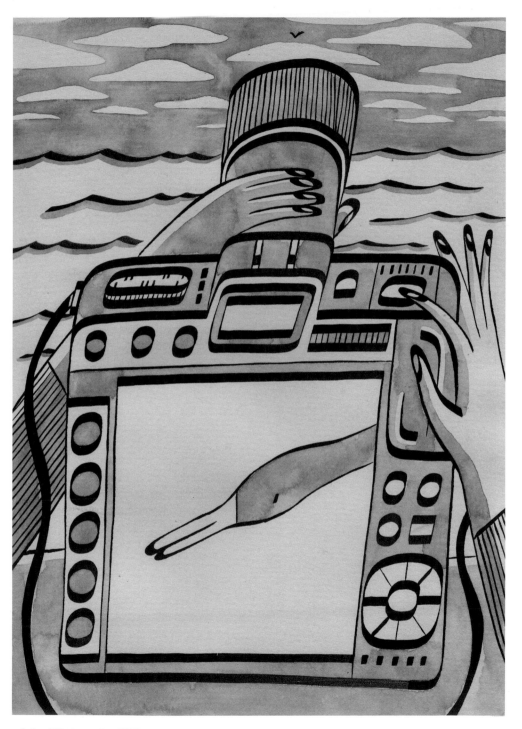

> Animal Photography, 2012.

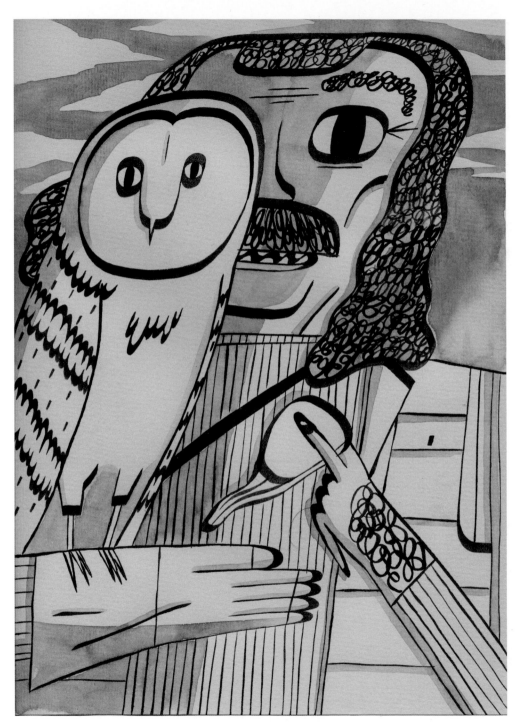

> Owlman, 2012.

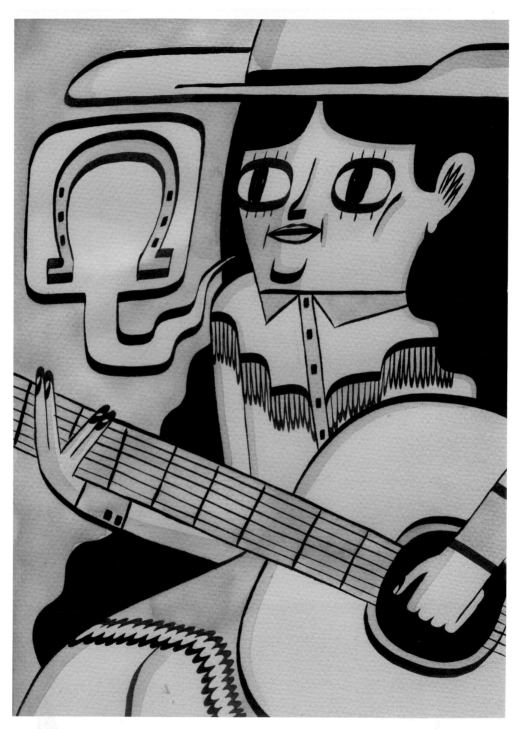

> Cowgirl, 2012.

Merijn
Hos

www.merijnhos.com

The Netherlands

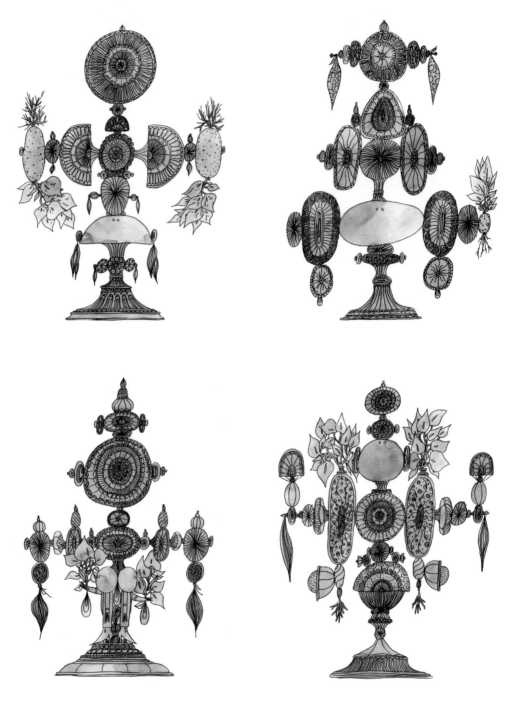

> Trophies series, 2012.

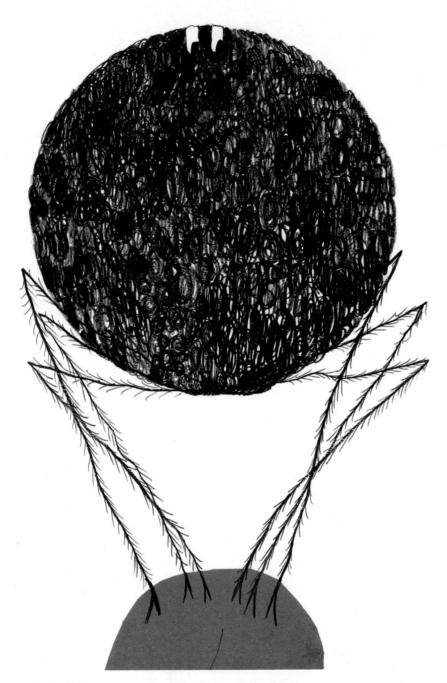

> Spider, 2010.

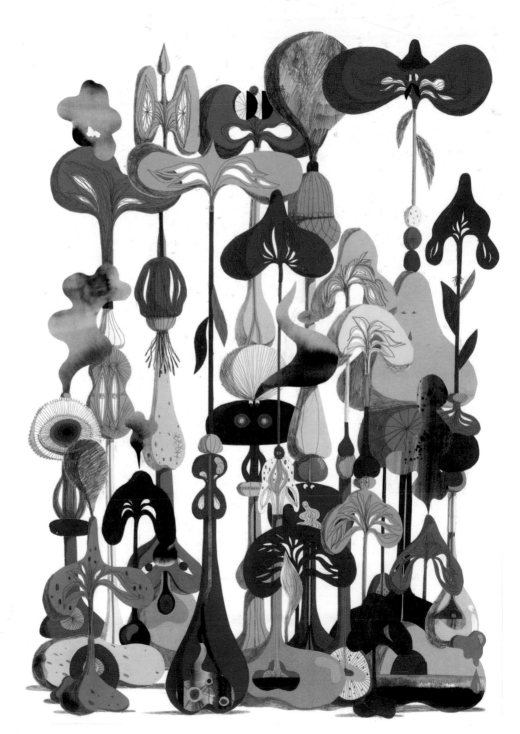

> Don't Worry Be Happy, 2010.

Takashi Iwasaki

www.takashiiwasaki.info

Japan

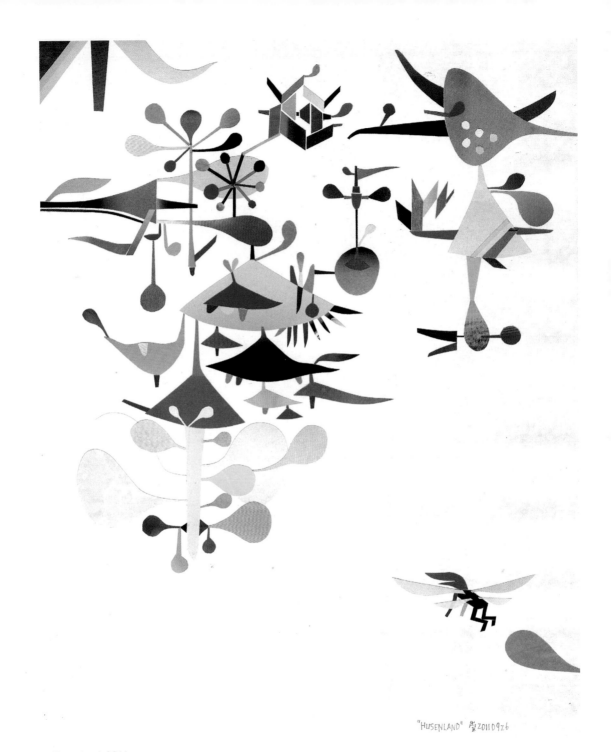

"HUSENLAND" 虛 20110926

> Husenland, 2011.

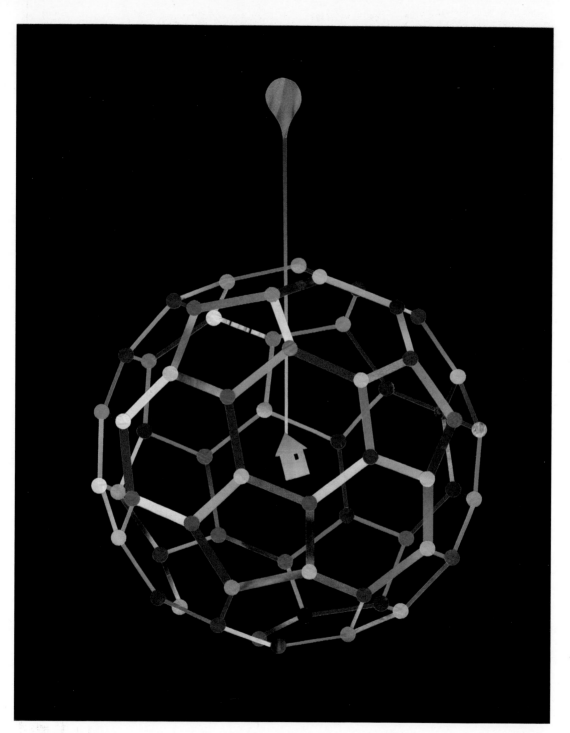

> C60 Shelter 8, 2011.

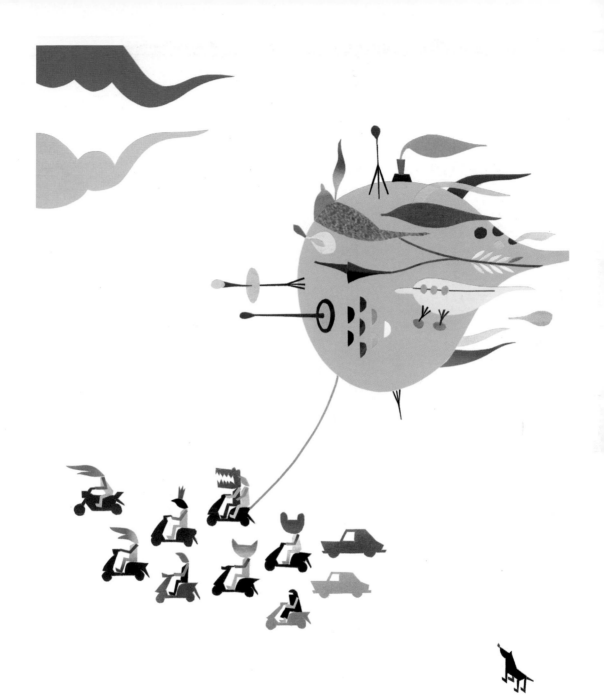

"A LITTLE BALLOON" 榮 20110624

> A Little Balloon, 2011.

Carl Johanson

www.carljohanson.com

Sweden

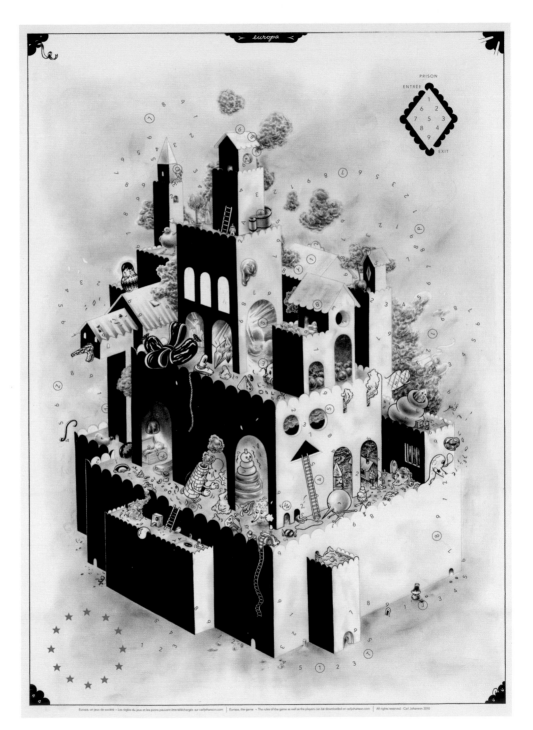

> Europa (the game), 2010.

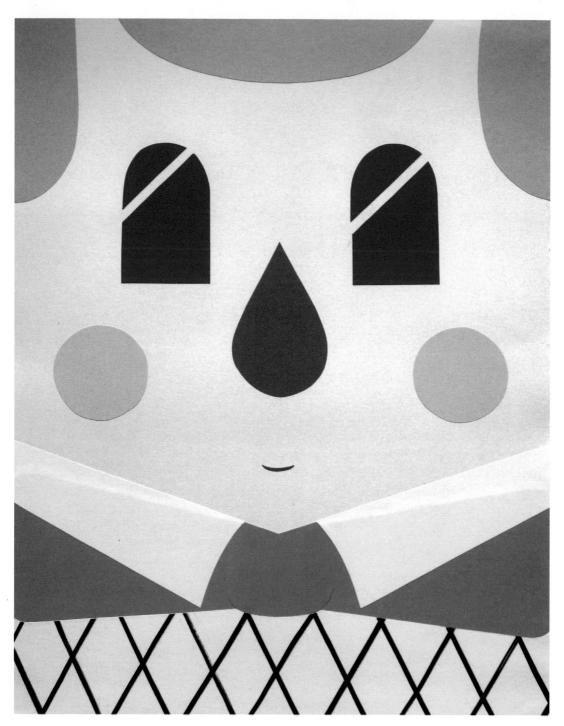

> Untitled, 2011.

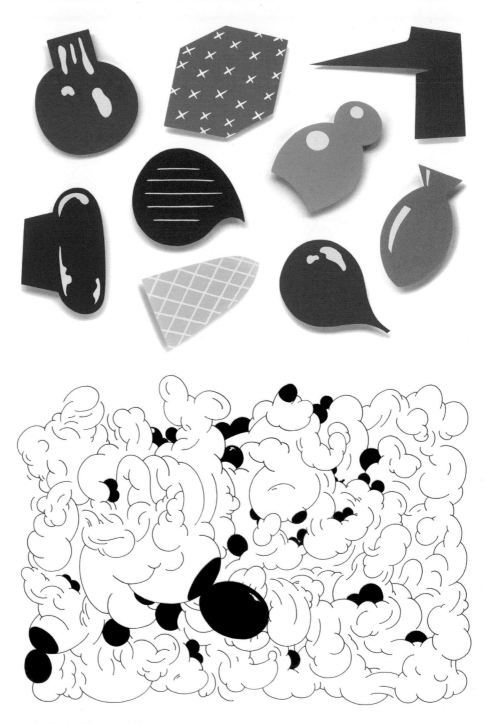

> Socials, 2012 – Whitney, 2008.

Viktor Khomenko

www.viktorwork.tumblr.com

Russia

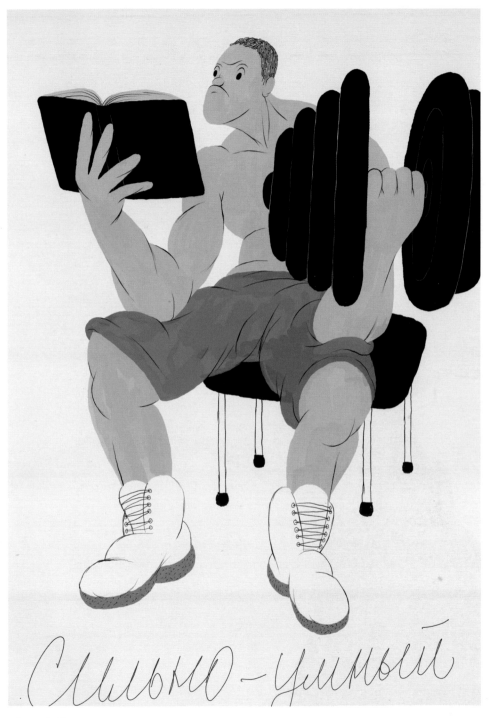

> Strongly Clever, 2011.

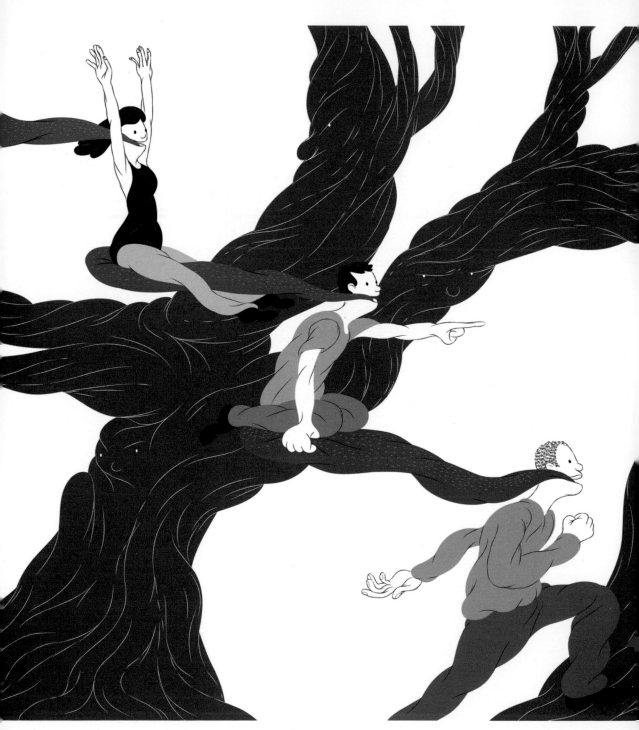

> Yazyki, 2011.

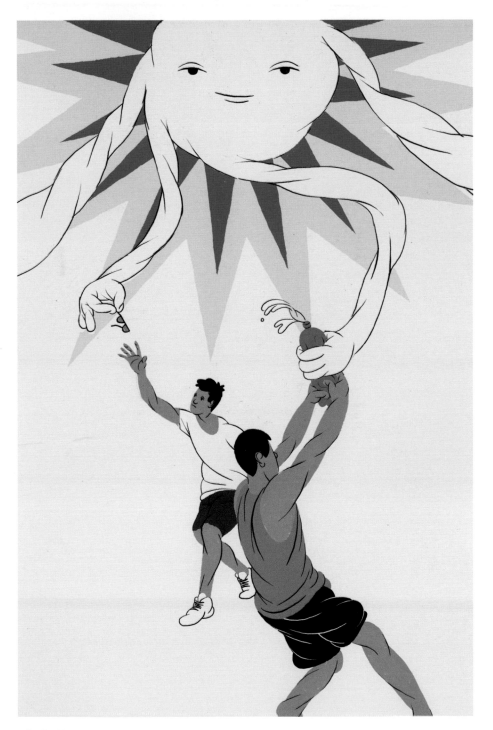

> Ouch, 2011.

Raymond Lemstra

www.raymondlemstra.nl

The Netherlands

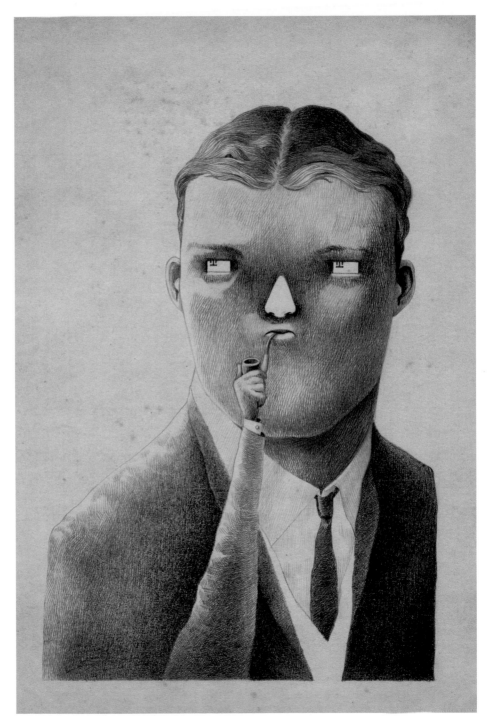

> Iobacco 4 (HMMM), 2011.

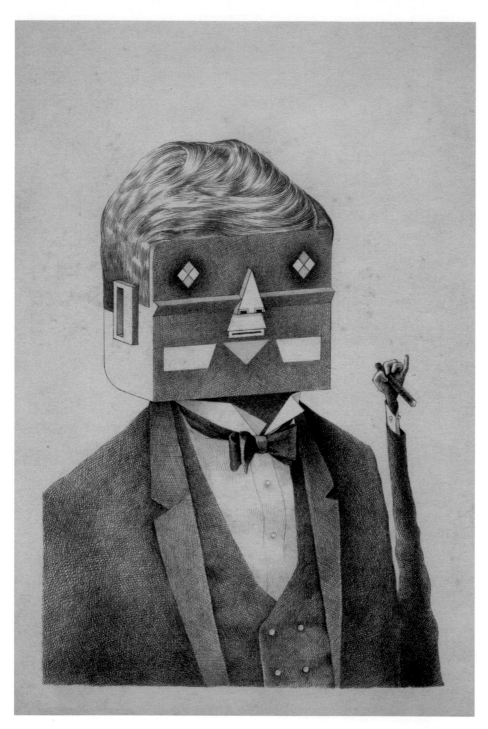

> Tobacco 1, 2011.

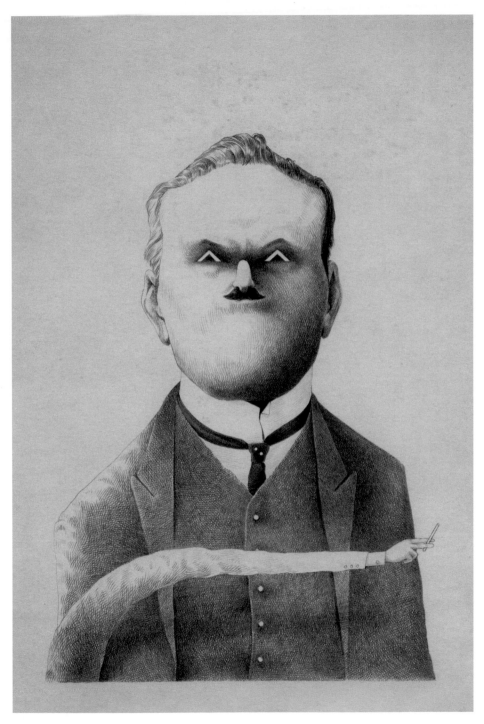

> Tobacco 3, 2011.

Bjørn Rune Lie

www.bjornlie.com

Norway

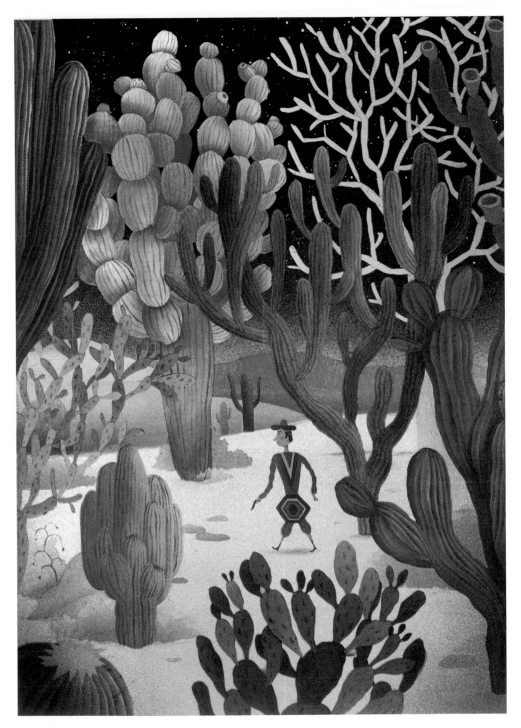

> Cactus Landscape, 2011.

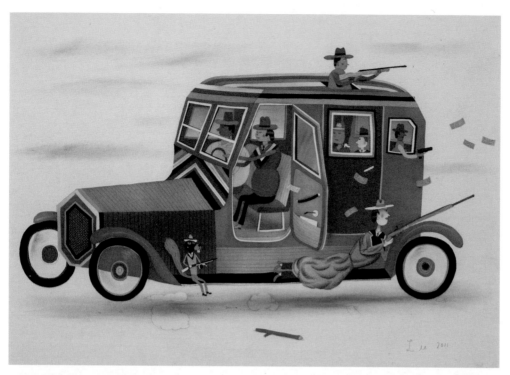

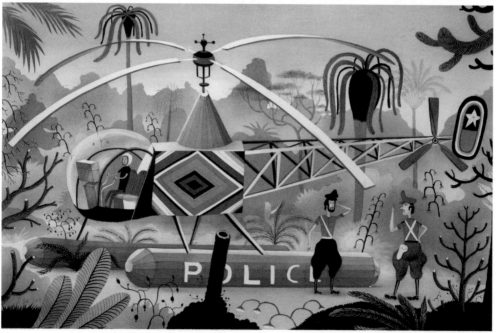

> The Getaway, 2011 – Police Helicopter, 2011.

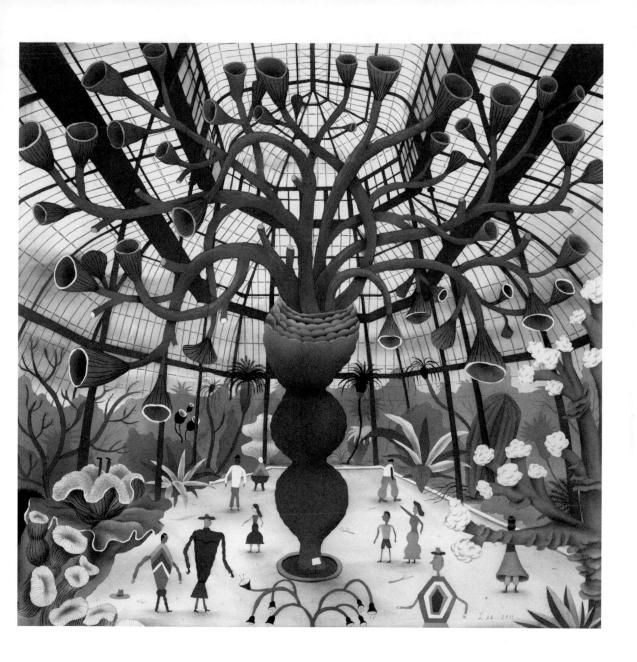

> The Glass House, 2011.

Kihyun Lim

www.kihyunlim.com

Korea

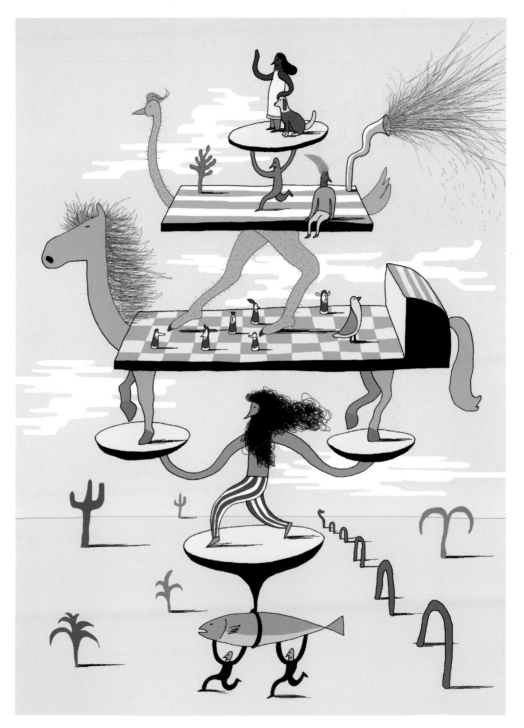

> Yellow Land, 2012.

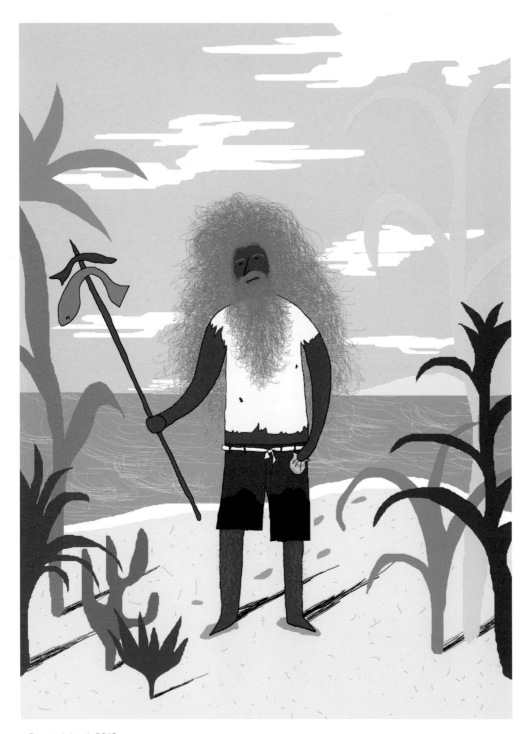

> Desert Island, 2012.

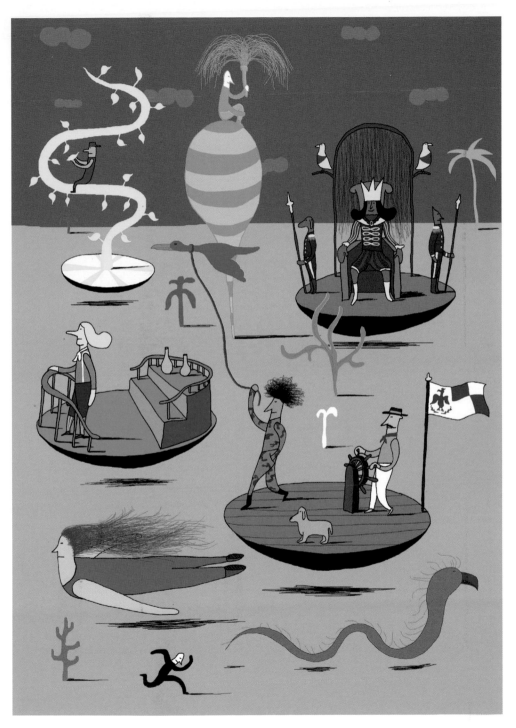

> Sail, 2012.

Alexey Luka

www.alexeyluka.com

Russia

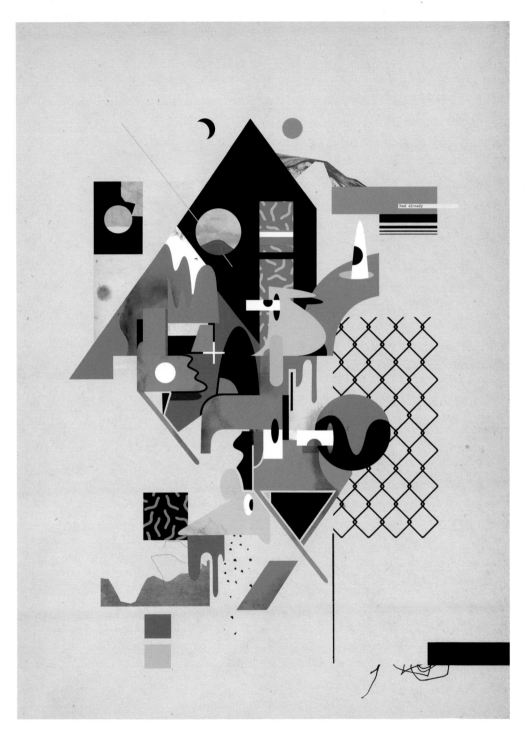

> Future, 2011.

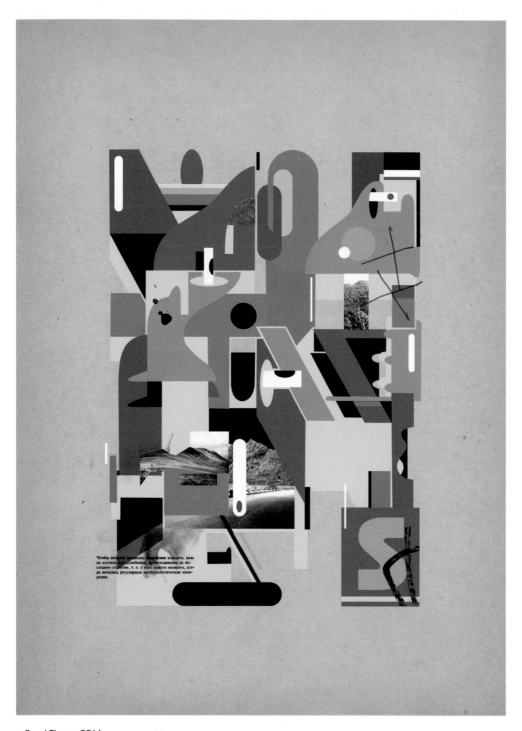

> Good Times, 2011.

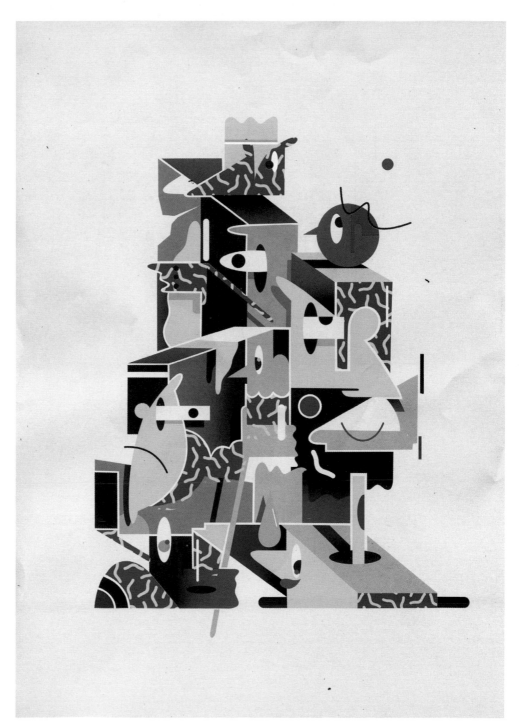

> Triangle, 2011.

Benjamin Marra

www.benjaminmarra.com

USA

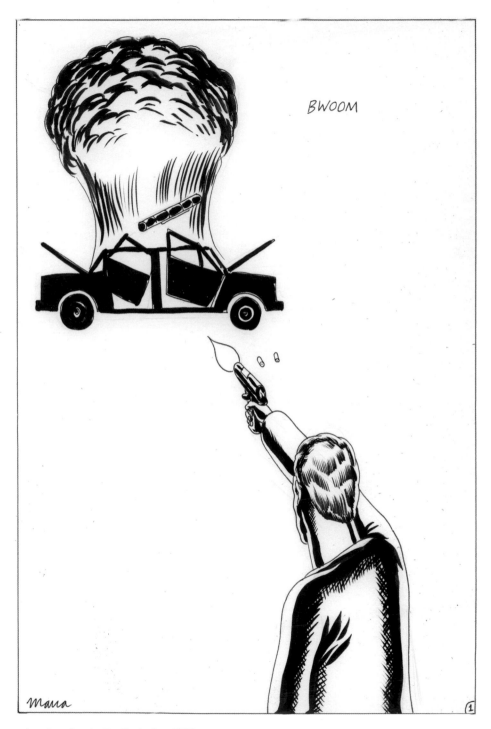

> American Psycho Car Explosion, 2008.

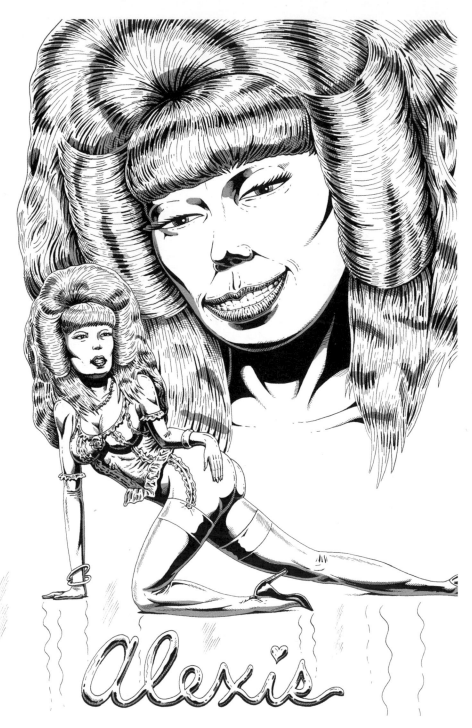

> Alexis Pin Up, 2008.

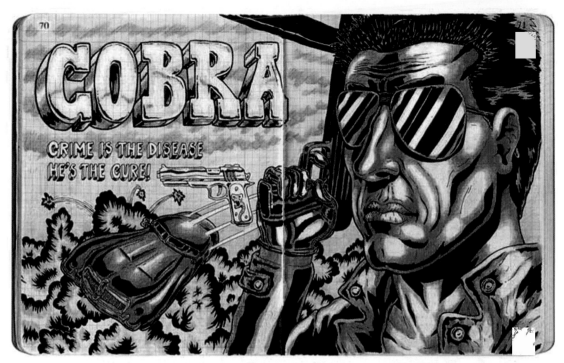

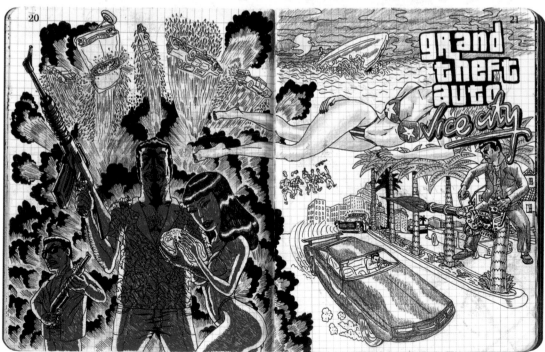

> Cobra – Vice.

Max-o-Matic

www.maxomatic.net

Spain

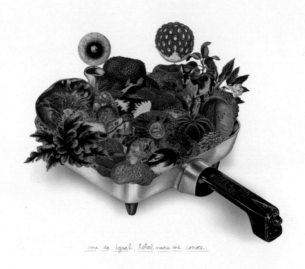

me da igual, total nadie me conoce.

> Raw. Fun. End. Now (Pan), 2011.

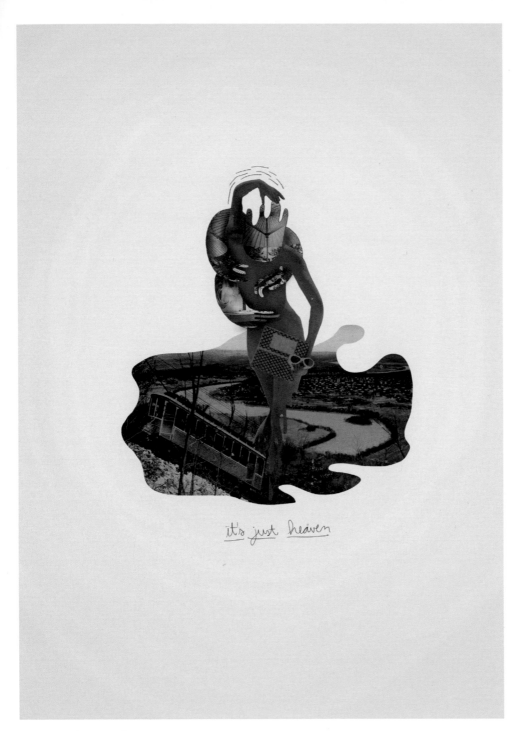

> Postcards (Transport), 2011.

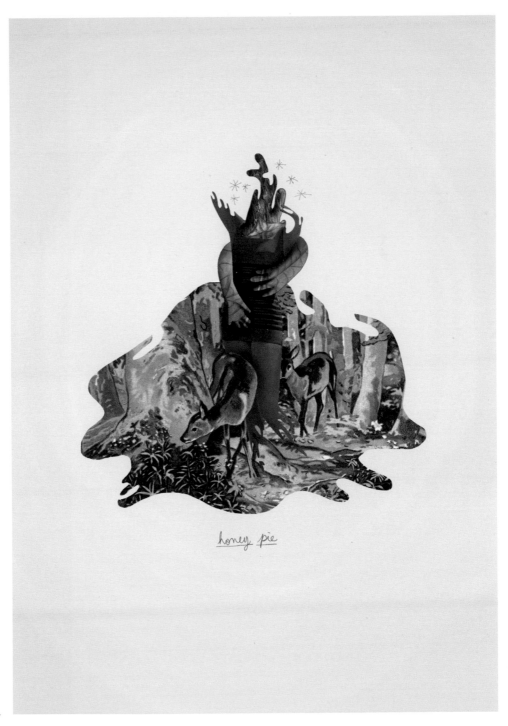

honey pie

> Postcards (Animals), 2011.

Toby
Neilan

www.tobyneilan.com

United Kingdom

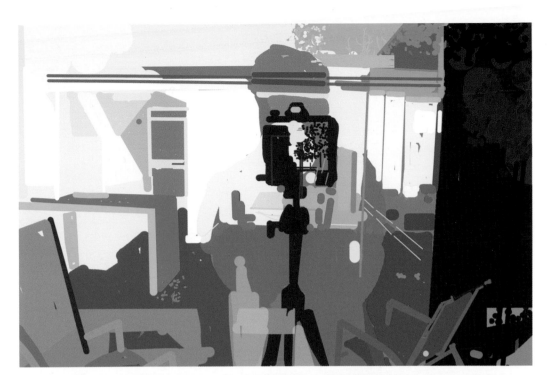

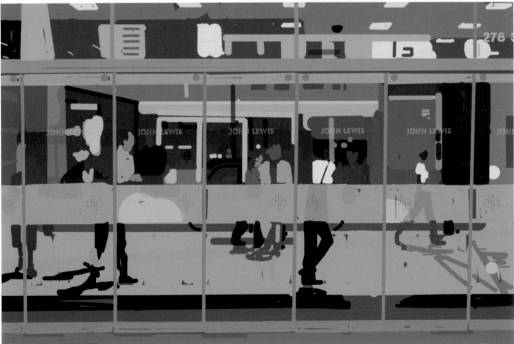

> Interiors/Reflections, 2012.

> London Fashion Week - Lights, 2012 — Southbank, 2012.

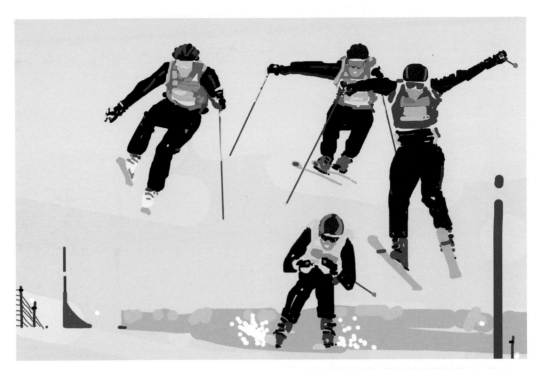

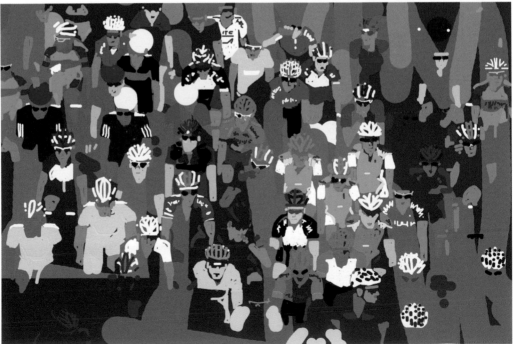

> Olympic, 2011.

Never Even Even/ Katherine Guillen, Eleanor Davis

www.doing-fine.com

USA

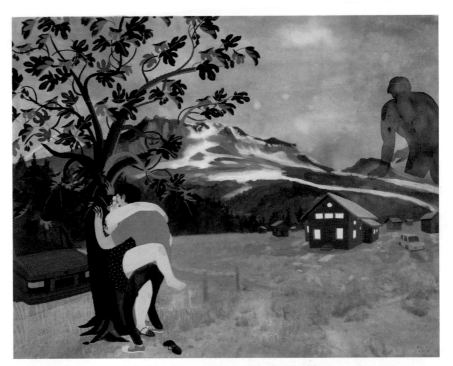

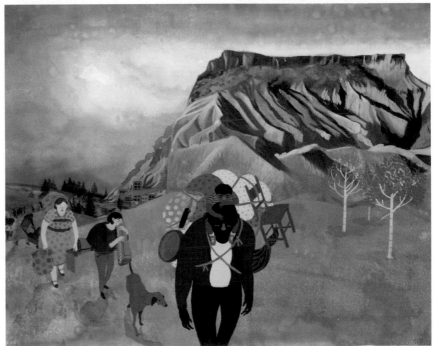

> Diplopia, 2010.

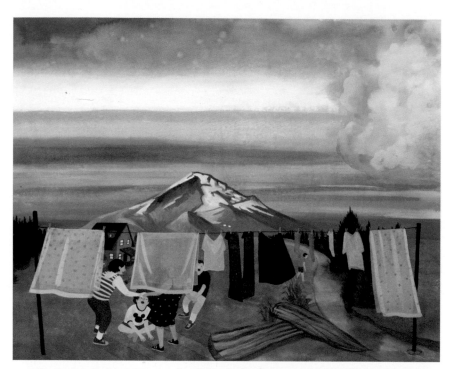

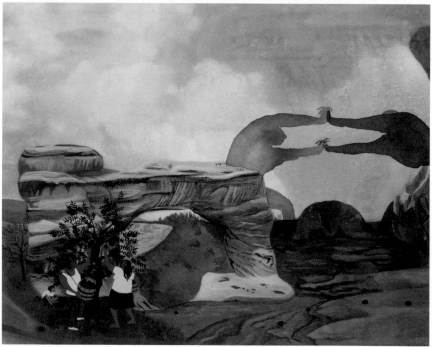

> Diplopia, 2010.

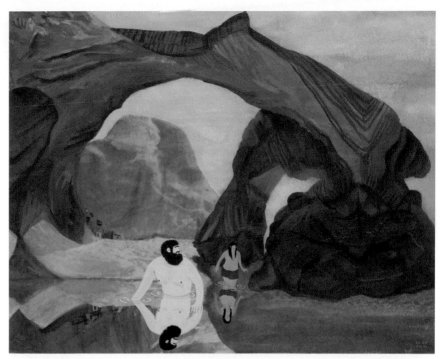

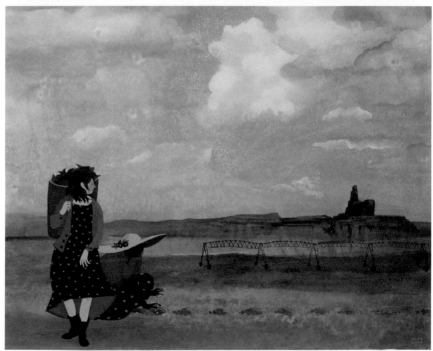

> Diplopia, 2010.

Akinori Oishi

www.aki-air.com

Japan

> Aki*DJs, 2011.

> Aki*Drawing, 2012.

> The Year of Aki*Dragon, 2012.

Ted
Parker

www.ted-parker.com

The Netherlands

> Dancing, 2011

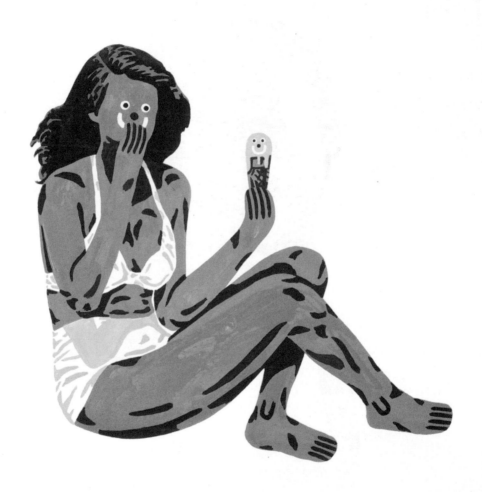

> Loves Ice Cream, 2011.

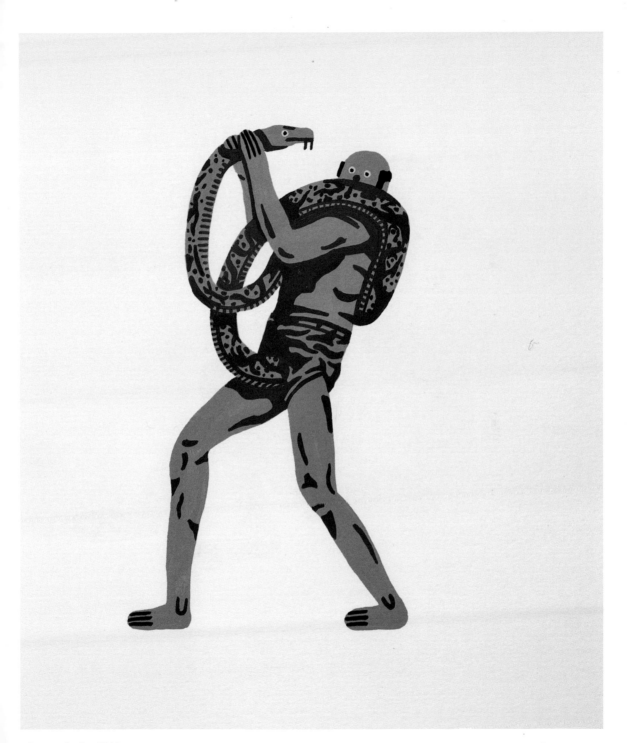

> Trouser Snake, 2011.

Ken
Postics

www.postics.com

France

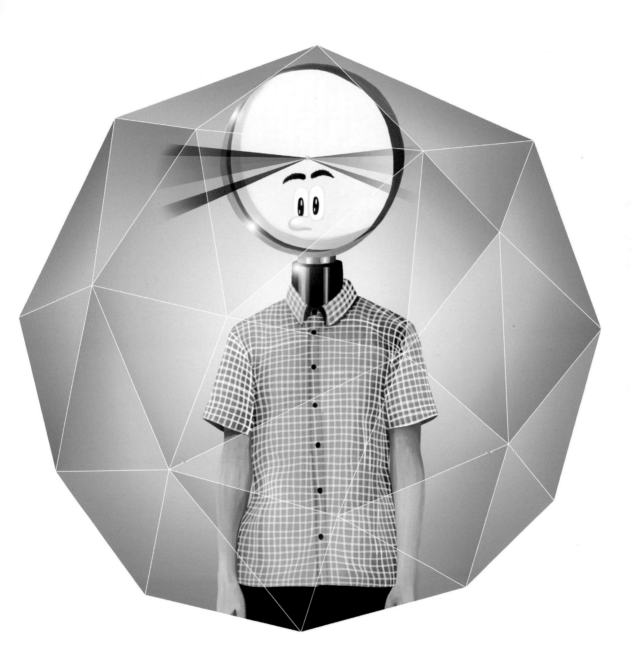

> Magnifying Glass, 2012.

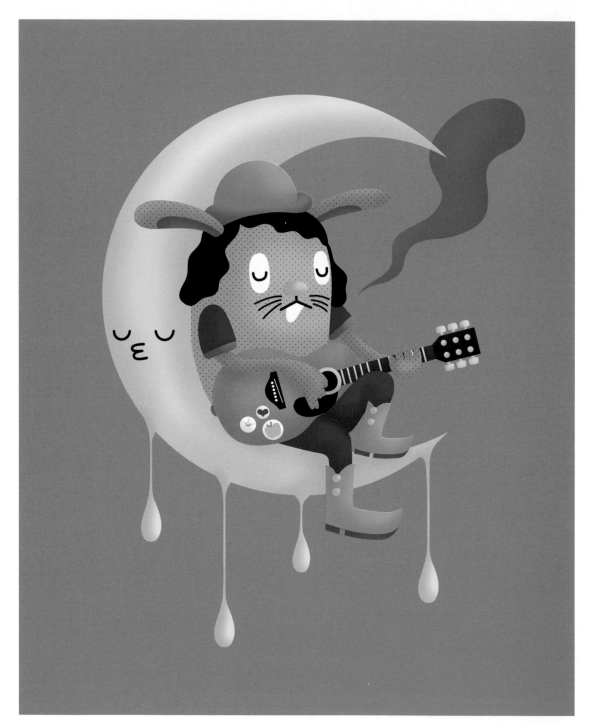

> Moon, 2011.

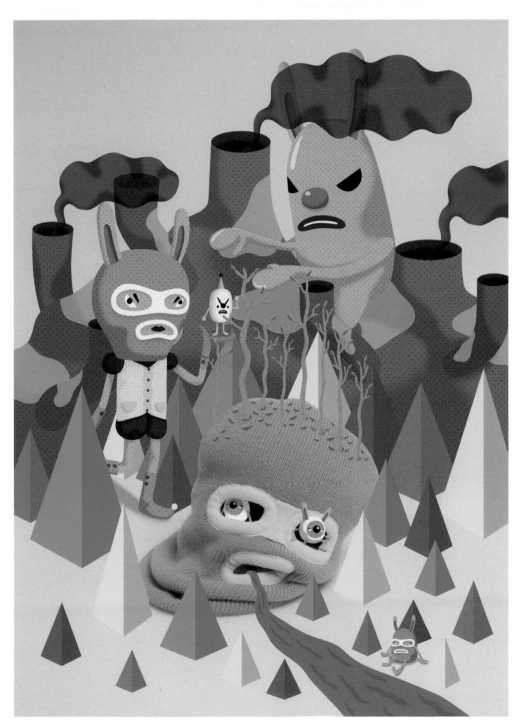

> Time Keeper, 2009.

Julia
Pott

www.juliapott.com

United Kingdom

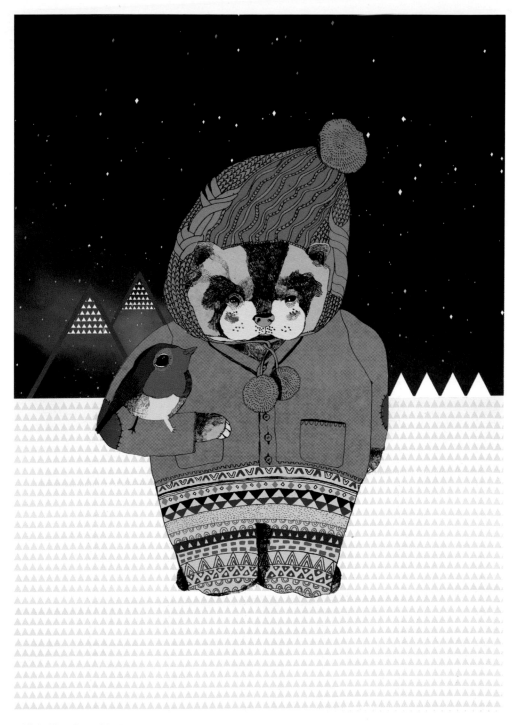

> Night Time Bear, 2009.

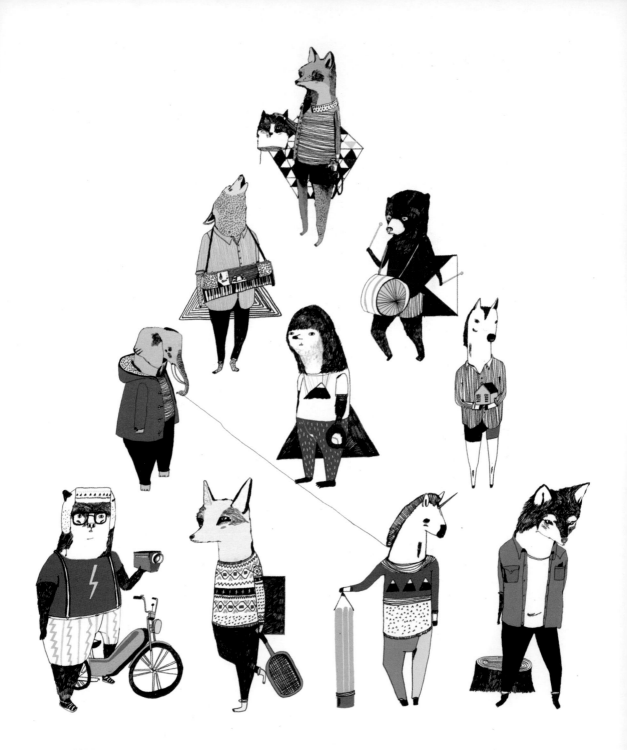

> Triangle, 2011.

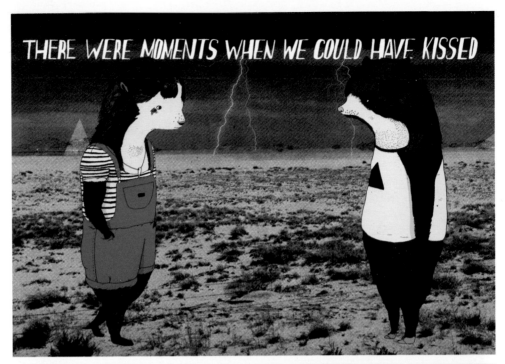

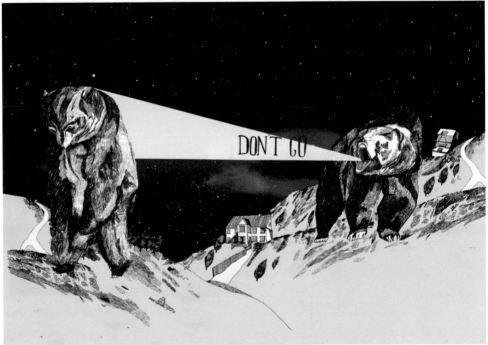

> Kissed, 2011 — Don't Go, 2010.

Luke Ramsey

www.lukeramseystudio.com

Canada

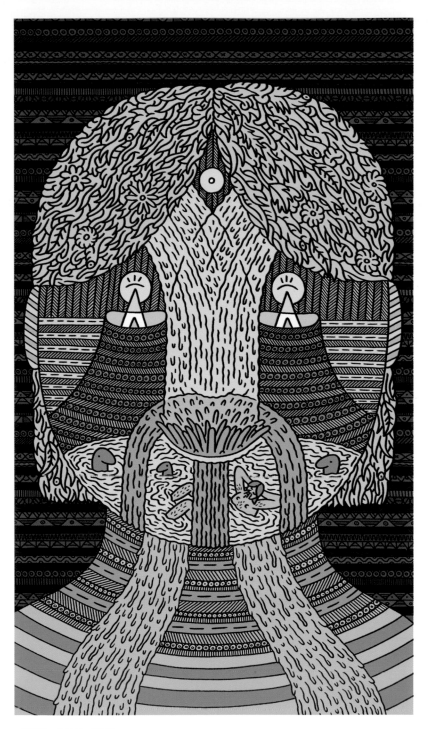

> Kill Devil Falls, 2009.

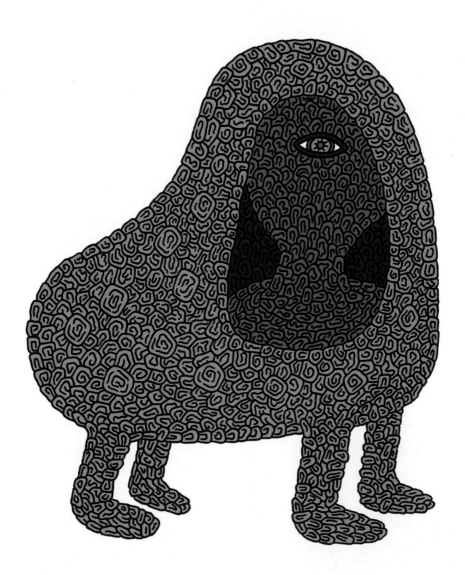

> Inner Eye, 2011.

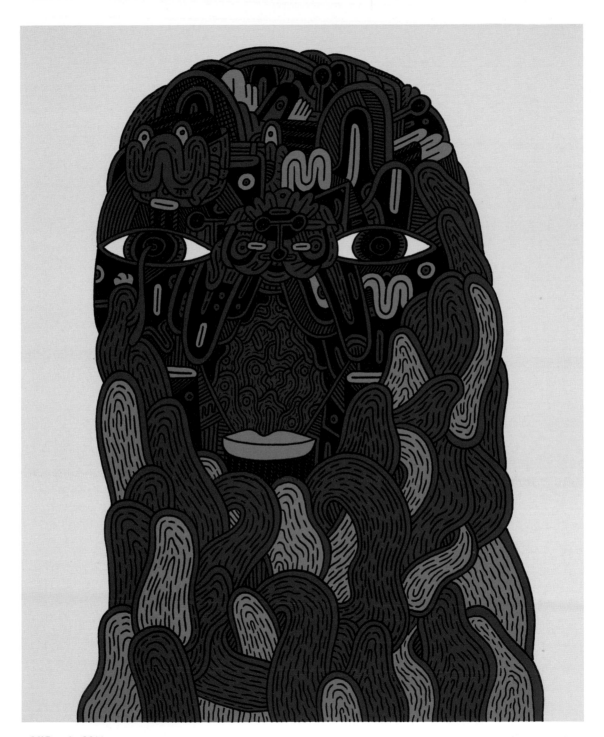

> Off Temple, 2011.

Malin Rosenqvist

www.malinrosenqvist.com

Sweden

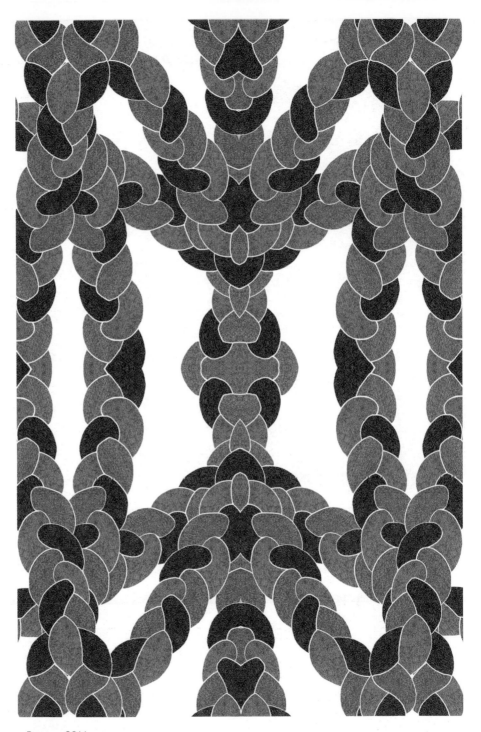

> Pattern, 2011.

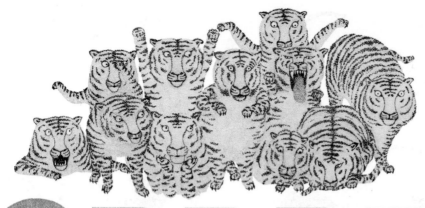

GRRRR

GRRREEN

> Grrrr, 2010 — Grrreen, 2010.

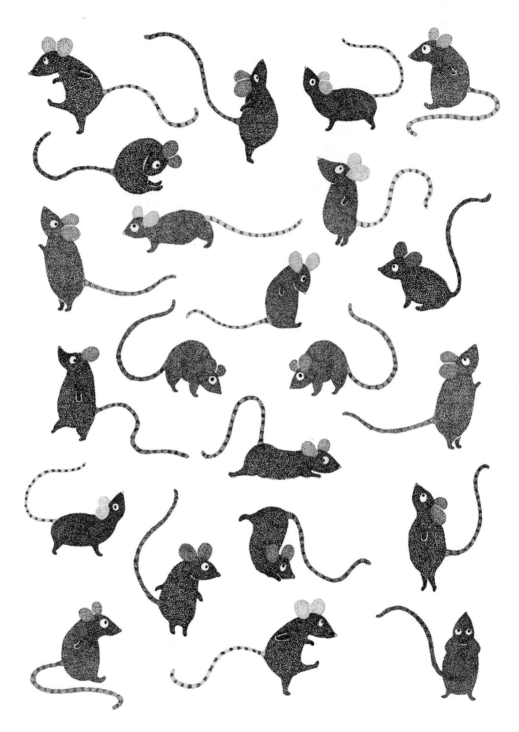

> Mice pattern, 2010.

Sac
Magique

www.sacmagique.net

Finland

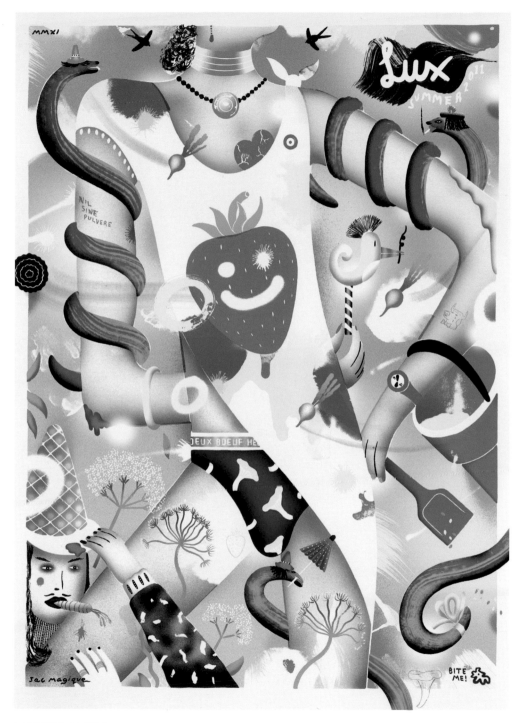

> Lux Summer, 2011.

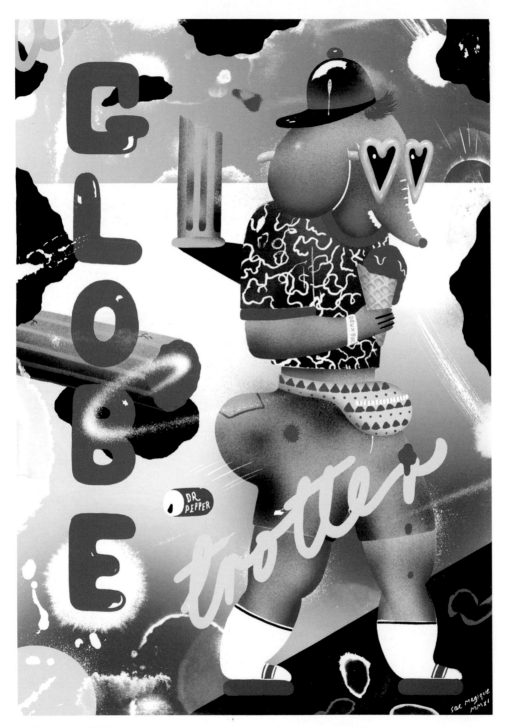

> Globe Trotter, 2011.

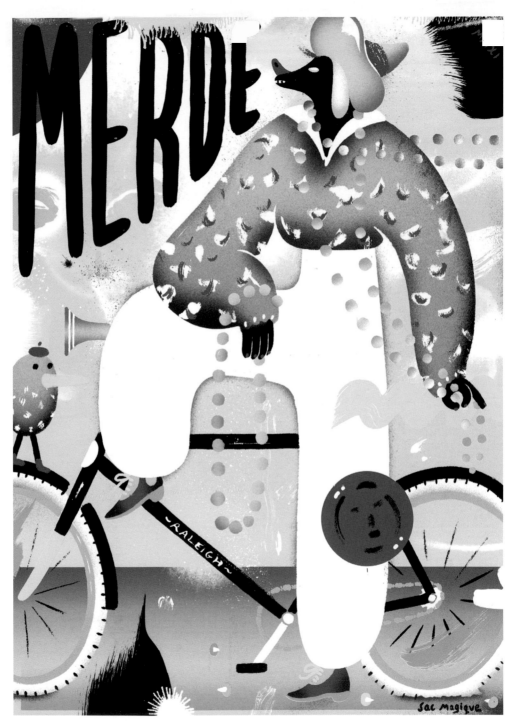

> Merde, 2011.

Ville
Savimaa

www.villesavimaa.com

Finland

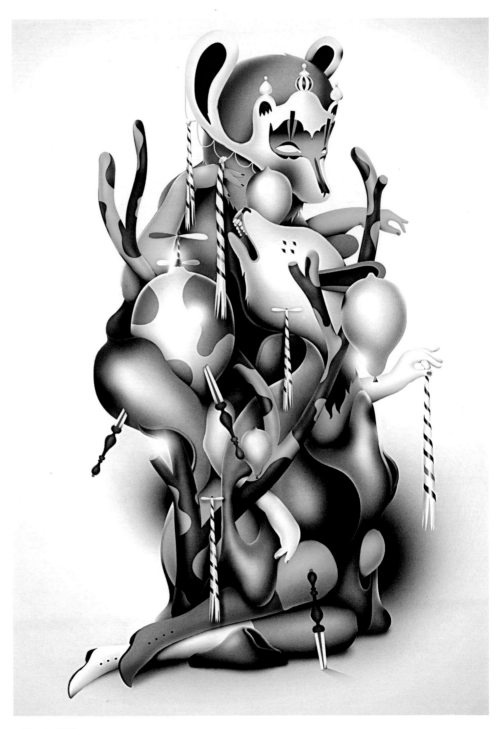

> Blue 1, 2012.

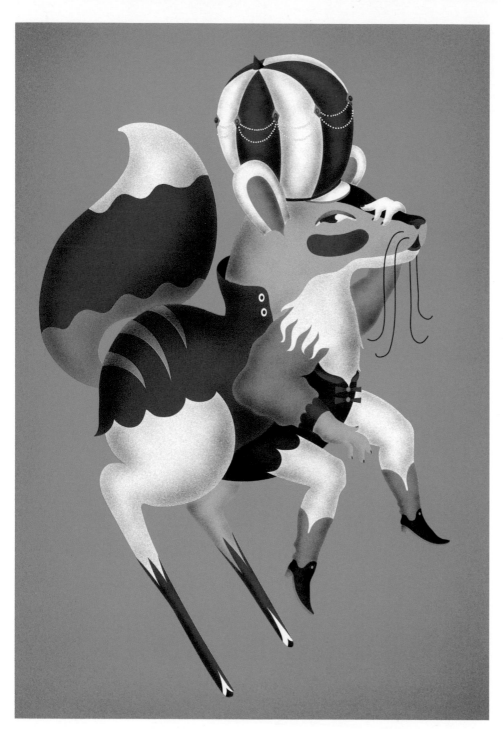

> Friend of the Marzipanking, 2010.

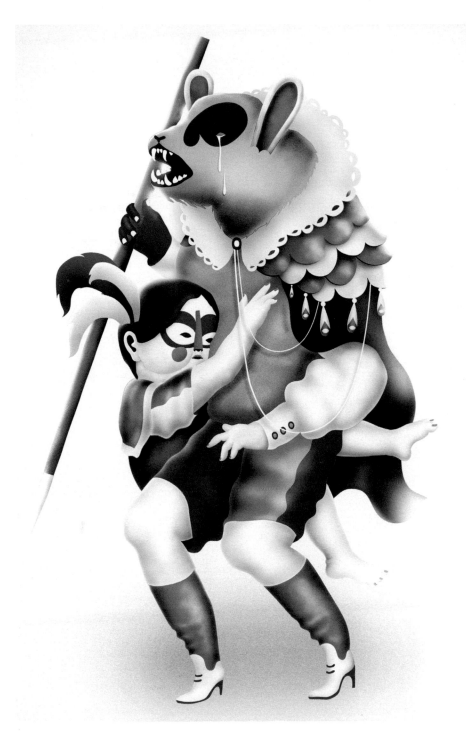

> Illegal Affair, 2009.

Karolin
Schnoor

www.karolinschnoor.co.uk

Germany

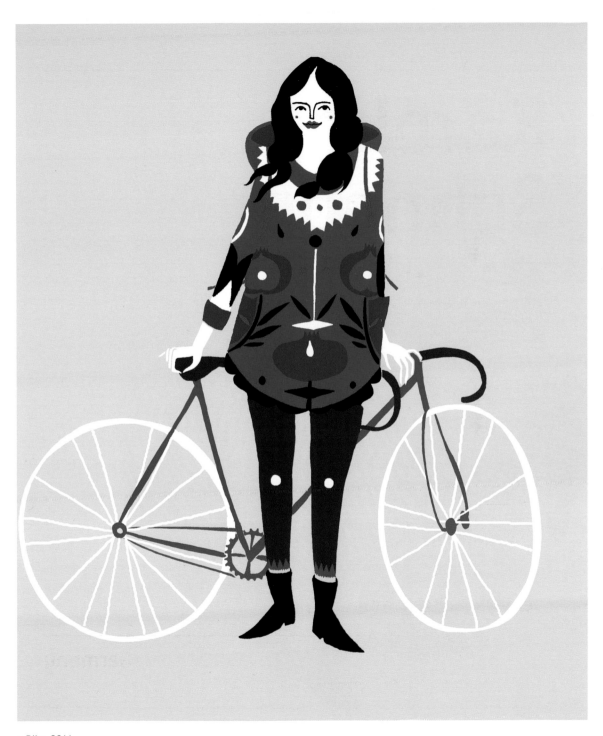

> Bike, 2011.

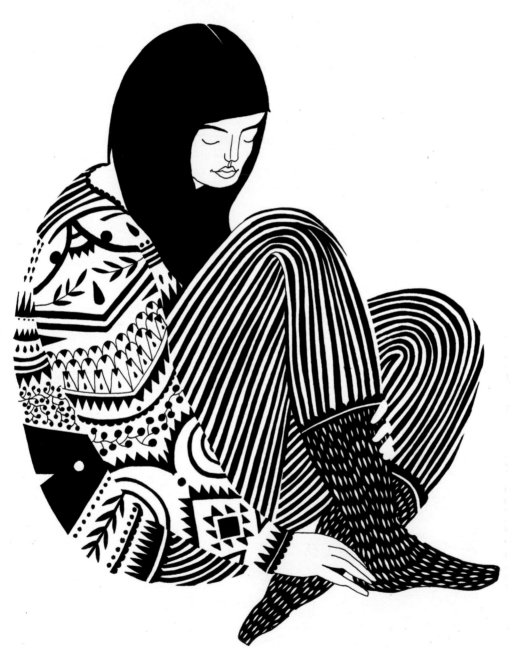

> Sweater, 2011.

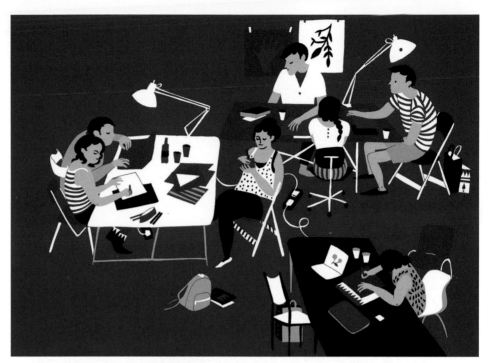

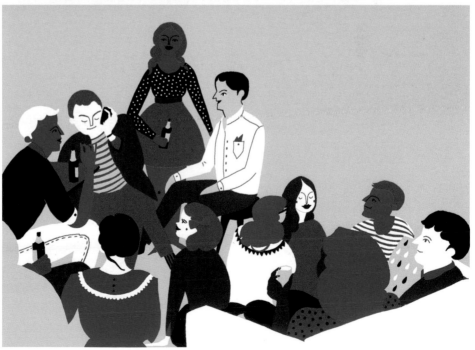

> Studio, 2011 — Party, 2012.

Katie
Scott

www.katie-scott.com

United Kingdom

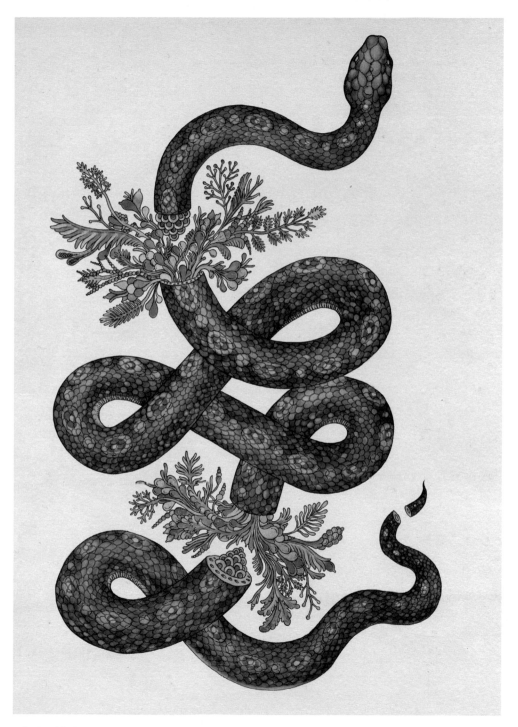

> Snake, 2011.

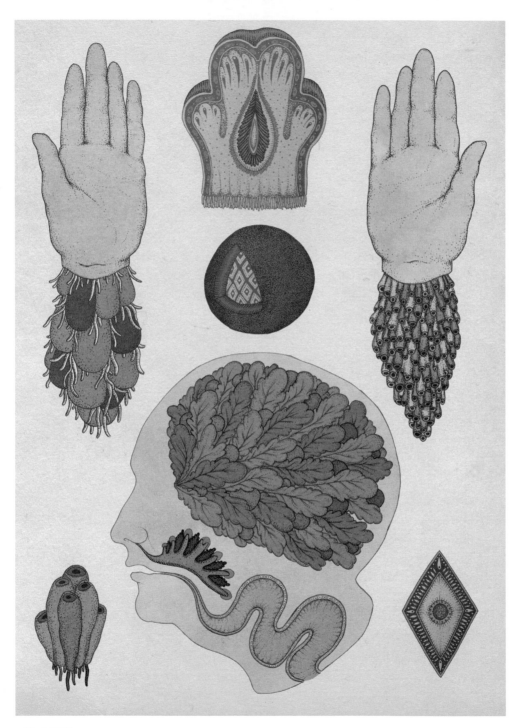

> Mind, 2011.

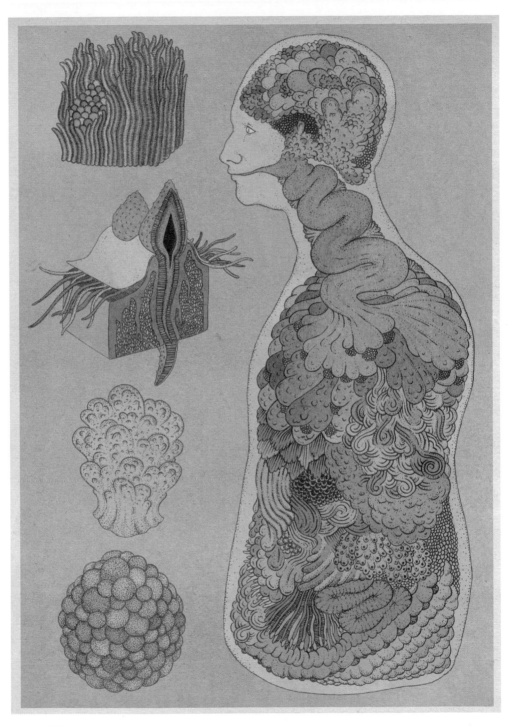

> Body, 2011.

Nicholas Stevenson

www.nicholasstevenson.com

United Kingdom

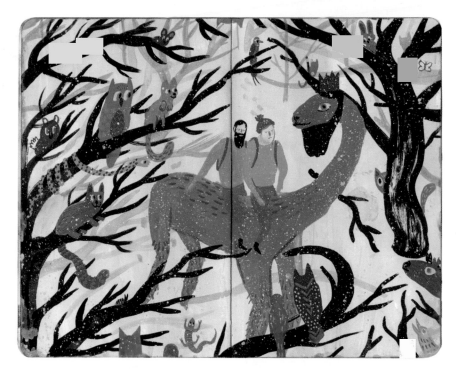

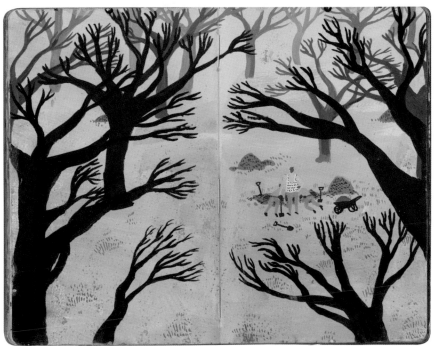

> Majoram, 2011 — The Woods, 2009.

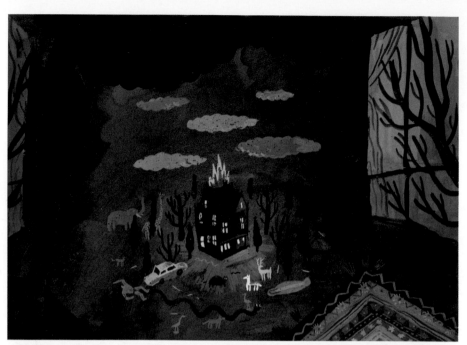

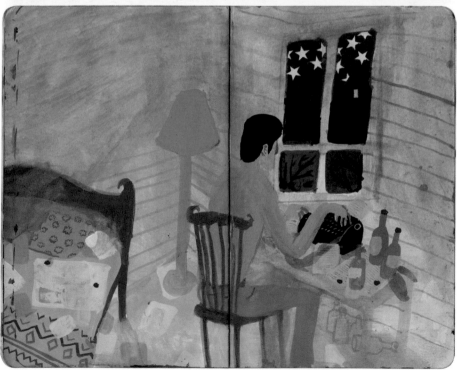

> House Fire, 2012 – Salem, 2011.

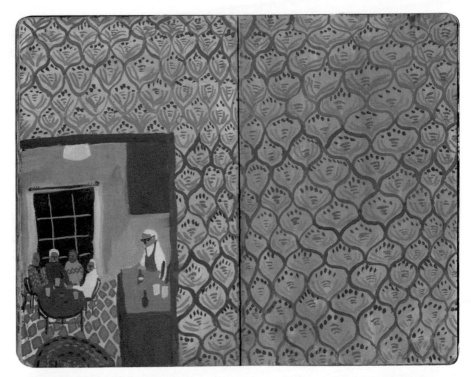

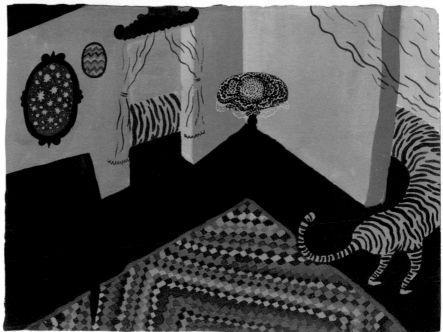

> The Bar, 2009 — The Tiger's Face #1, 2011.

Antti Uotila

www.anttiuotila.com

Finland

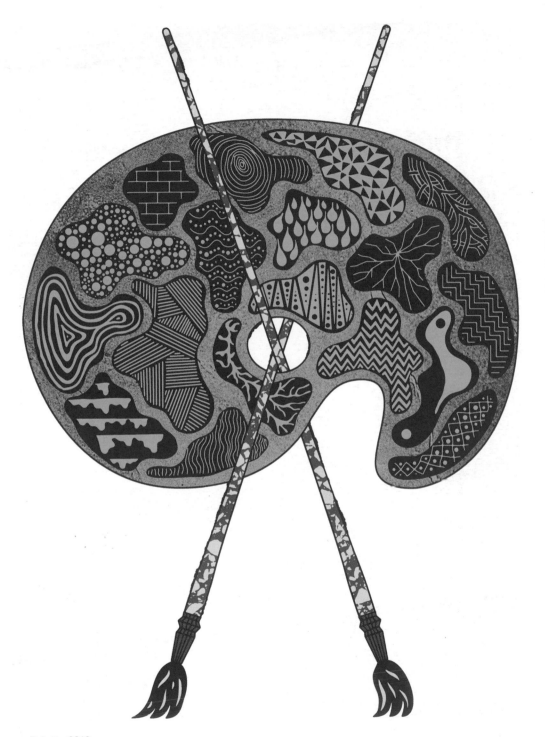

> Palette, 2010.

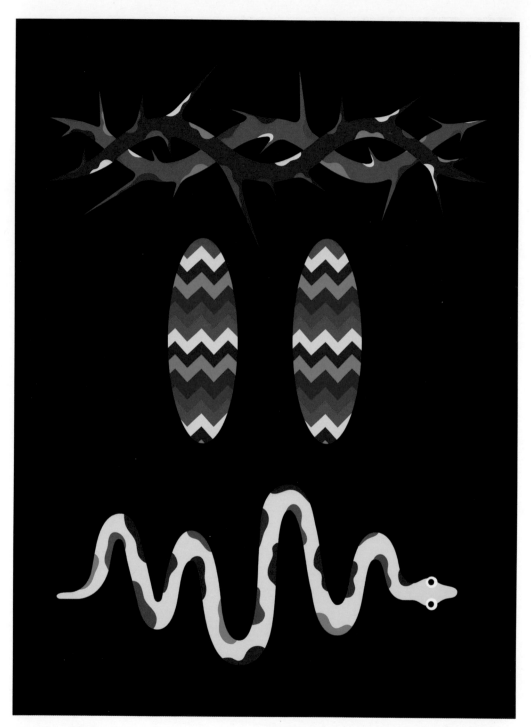

> Jesus 1, 2010.

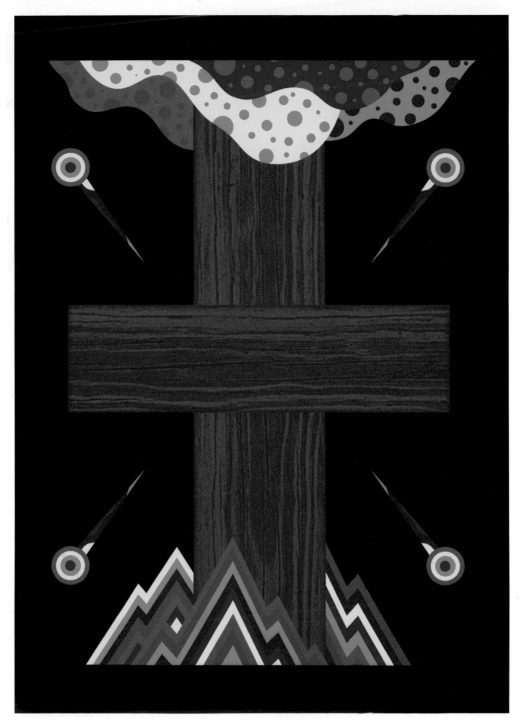

> Jesus 2, 2010.

Tyra von Zweigbergk

www.tyraillustrations.blogspot.de

Sweden

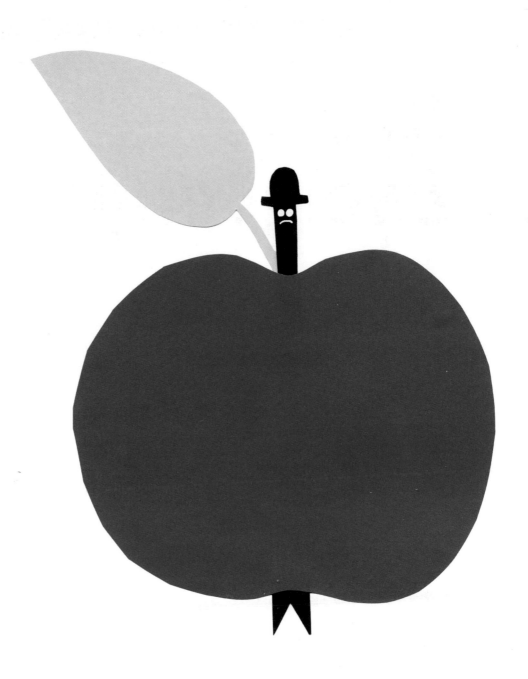

> Applehead, 2010.

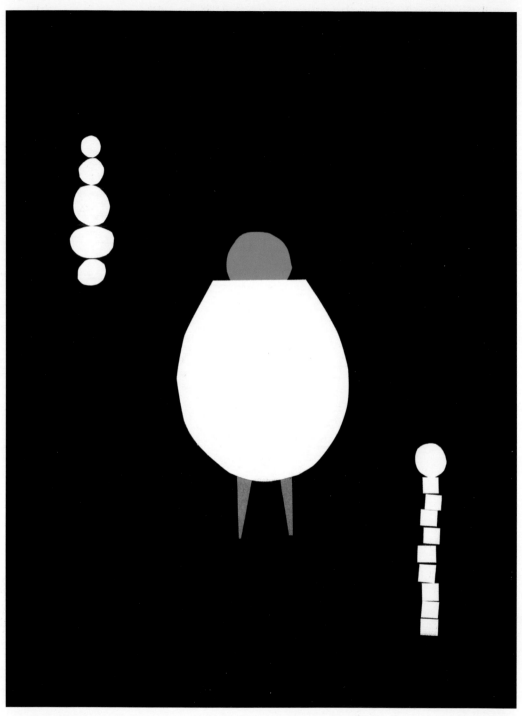

> Building, 2011.

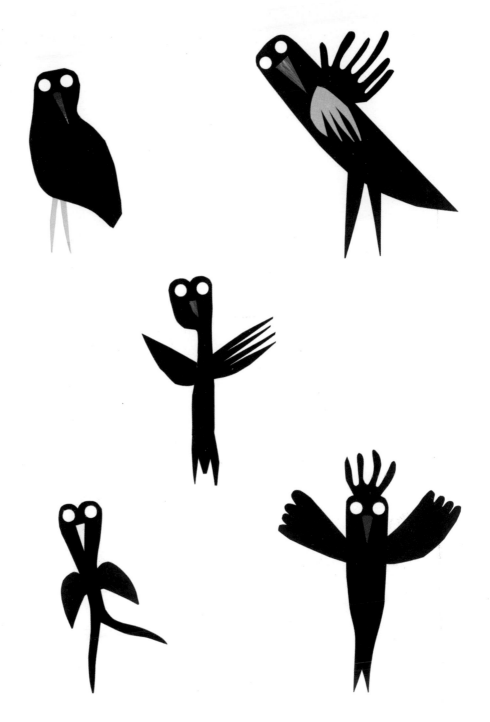

> Birdshow, 2010.

Holly
Wales

www.hollywales.com

United Kingdom

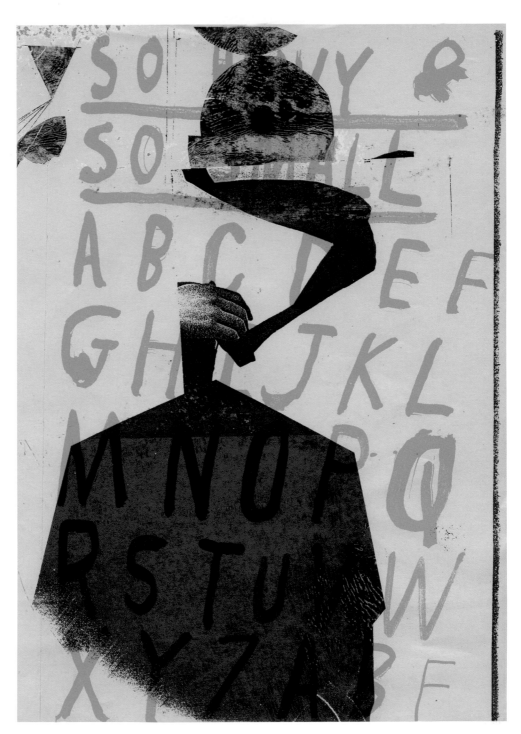

> Untitled, 2012.

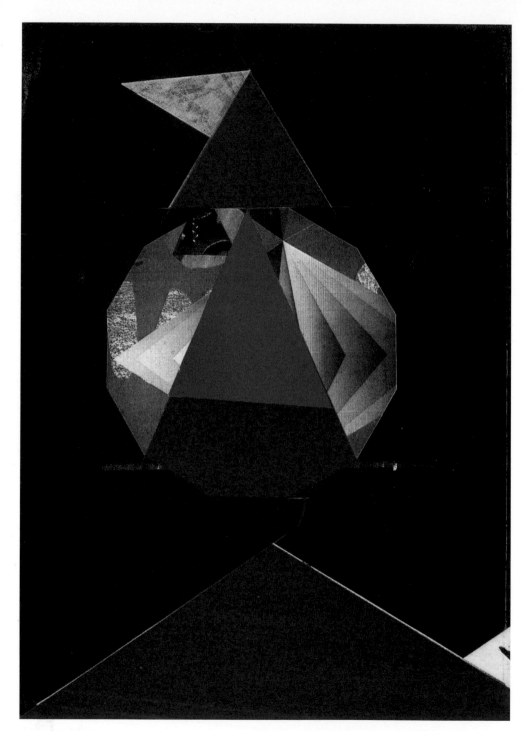

> Untitled, 2012.

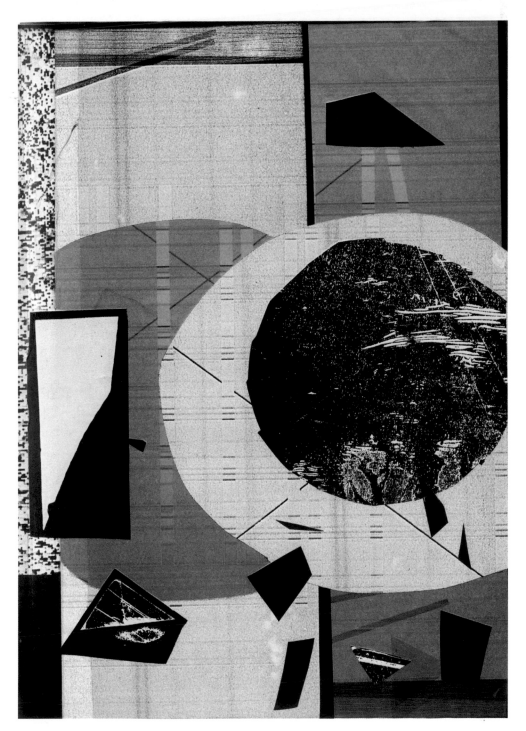

> Untitled, 2012.

Andrea
Wan

www.andreawan.com

Canada

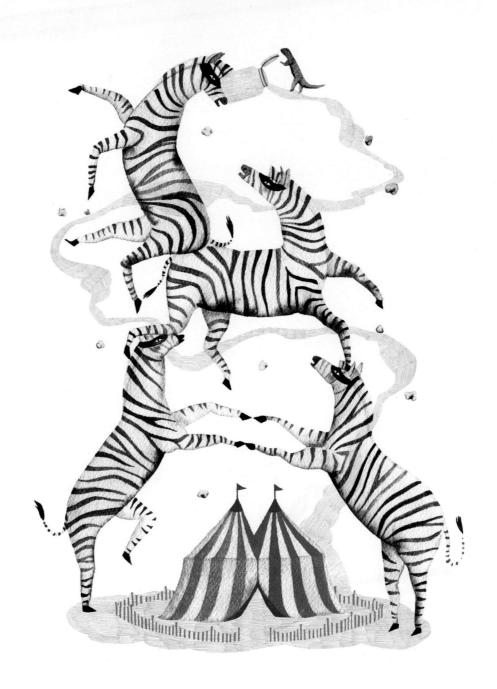

> Lurch1, 2012.

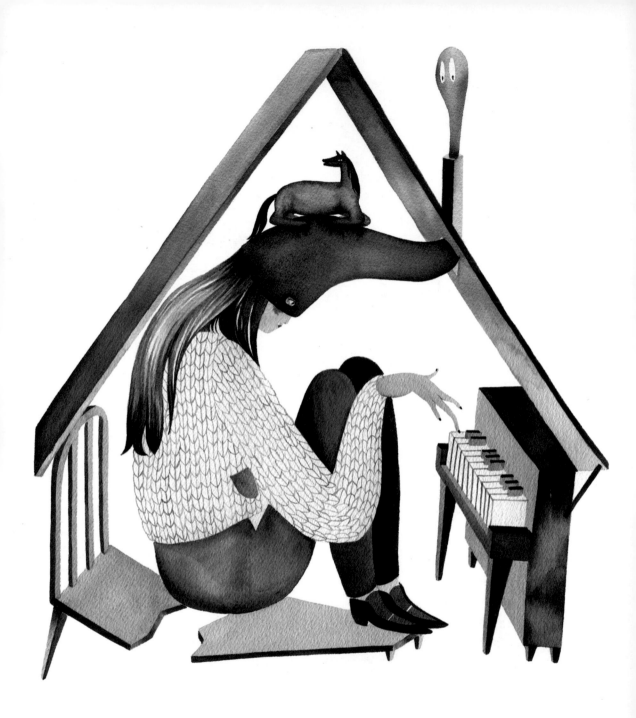

> Monday, 2011.

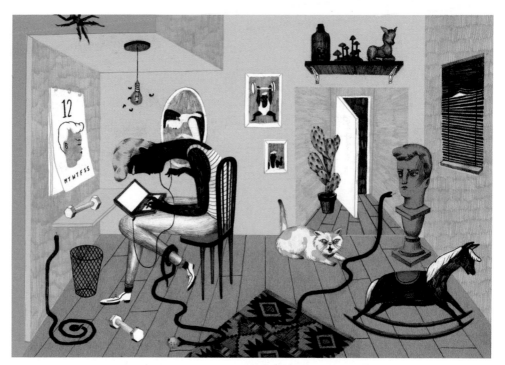

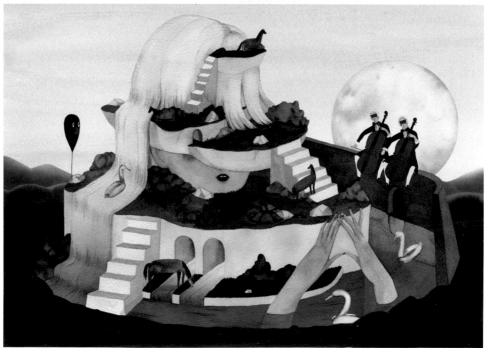

> NB02, 2011 – Strange Daze, 2012.

Kimiaki Yaegashi

www.okimi.com

Japan

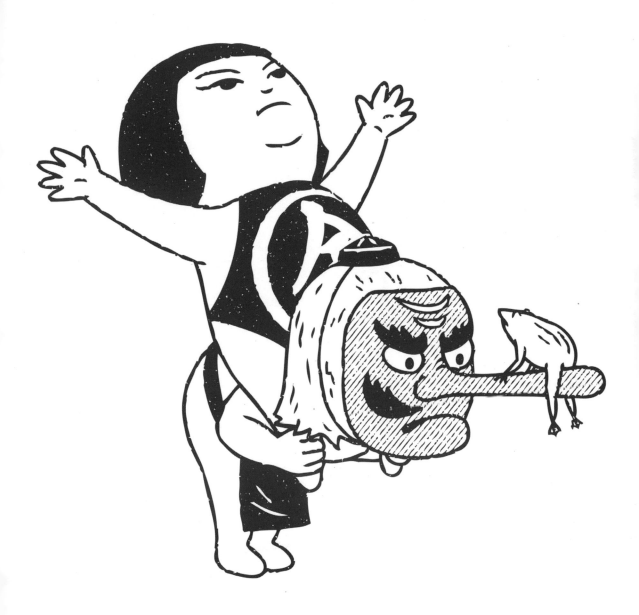

> Kata-Guruma, 2011.

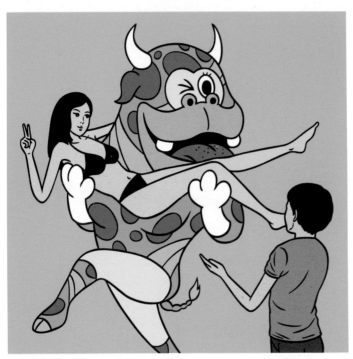

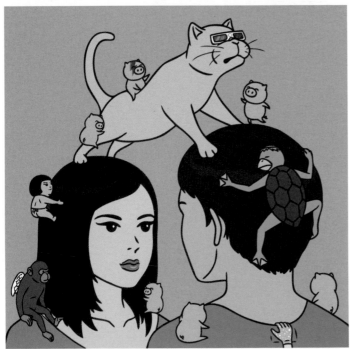

> Monster 07, 2009 — New Confession, 2010.

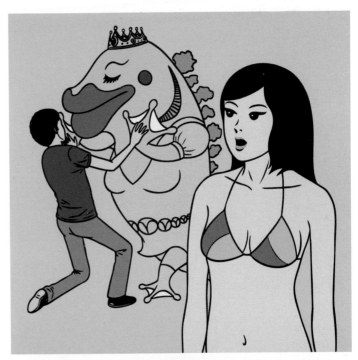

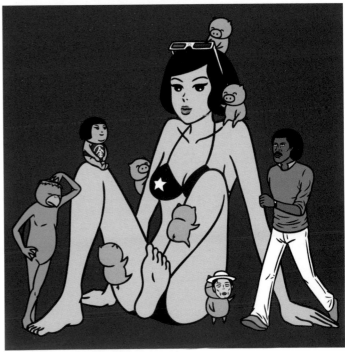

> Monster 09, 2009 – Mountain Girl, 2010.

Yoko
Nono

http://velourcru.blogspot.de

France

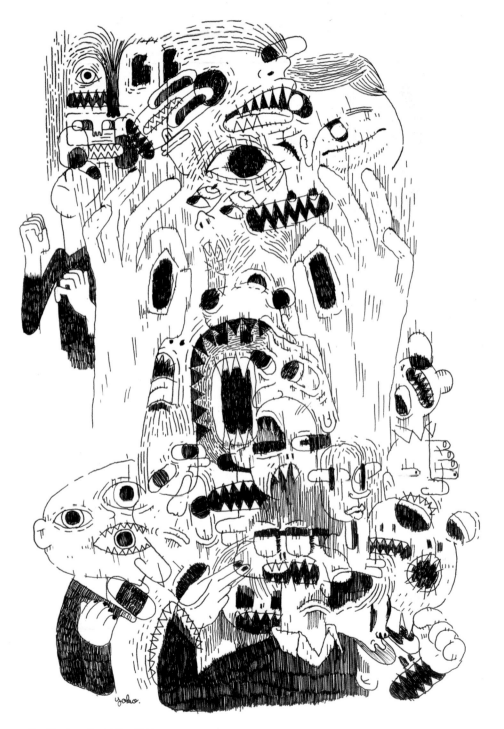

> See You in a Next Life, 2011.

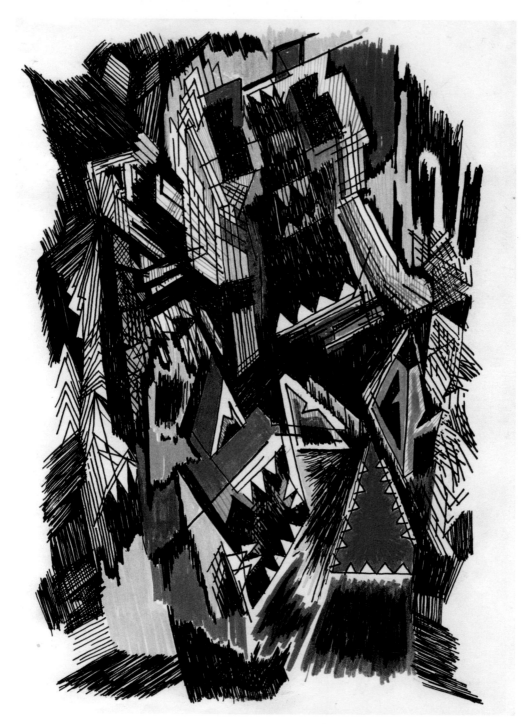

> Gonestop, 2011.

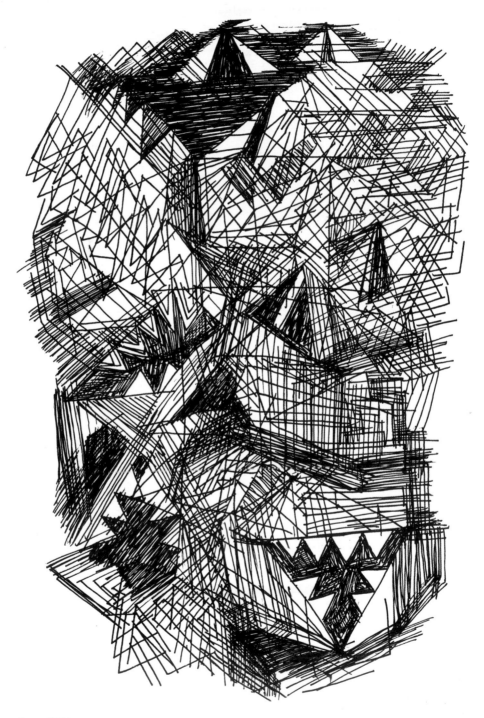

> Scum, 2011.

Yeji Yun

www.seeouterspace.com

South Korea

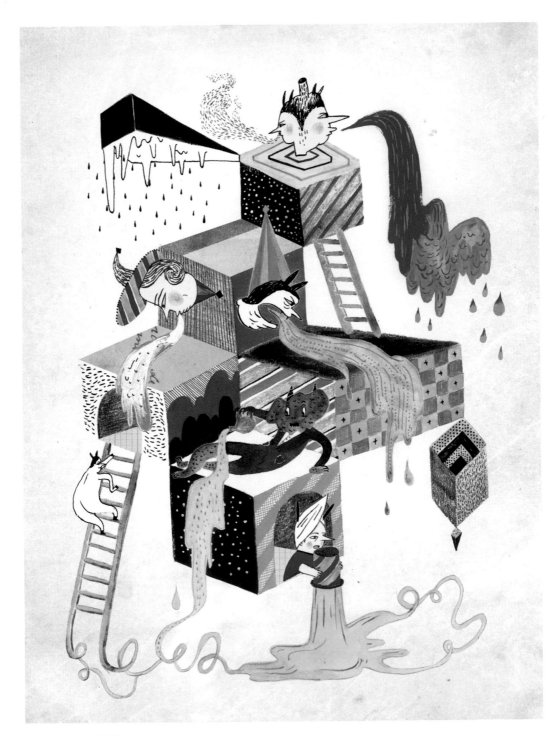

> Pucky Village, 2010.

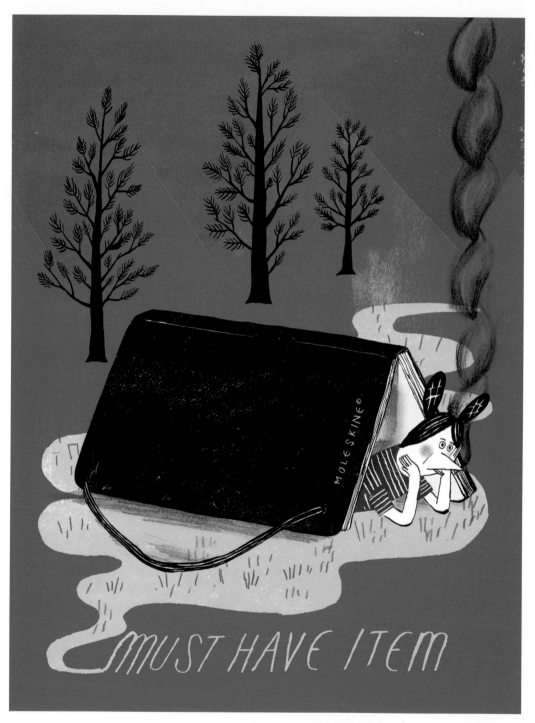

> Modern Series, 2011.

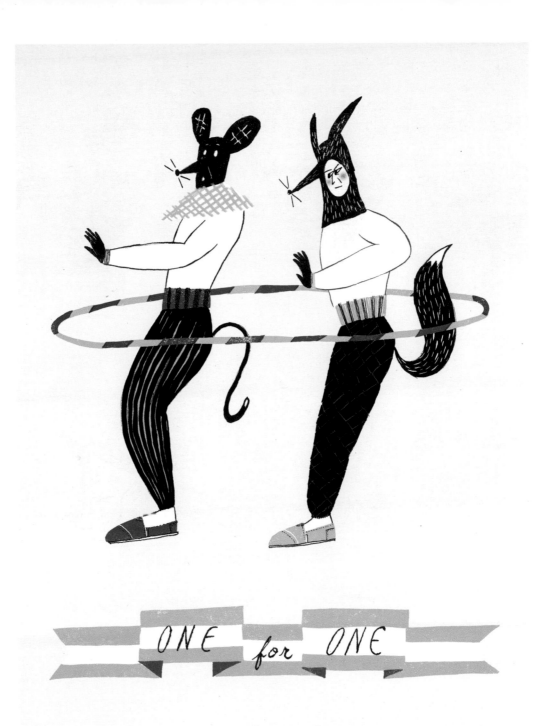

> Modern Series, 2011.

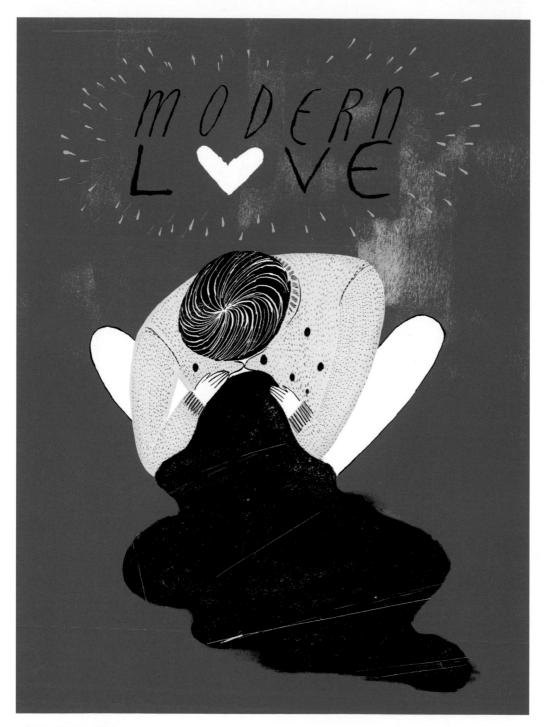

> Modern Series, 2011.

MODERN SOLITUDE

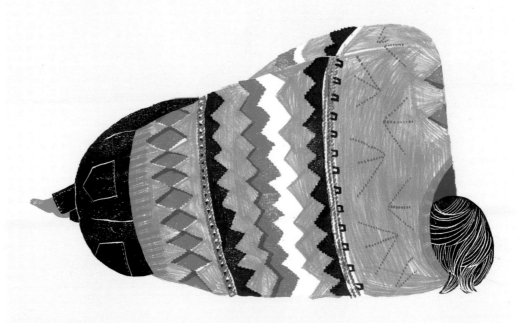

> Modern Series, 2011.